W9-DJK-350

BK 758.409 C362A
AMERICAN STILL LIFE, 1945-1983
 /CATHCART,
 C1983 25.20 FV

3000 667301 30019
St. Louis Community College

758.409 C362a F V
CATHCART
AMERICAN STILL LIFE, 1945-1983
 25.20

WITHDRAWN

St. Louis Community
College

Library

5801 Wilson Avenue
St. Louis, Missouri 63110

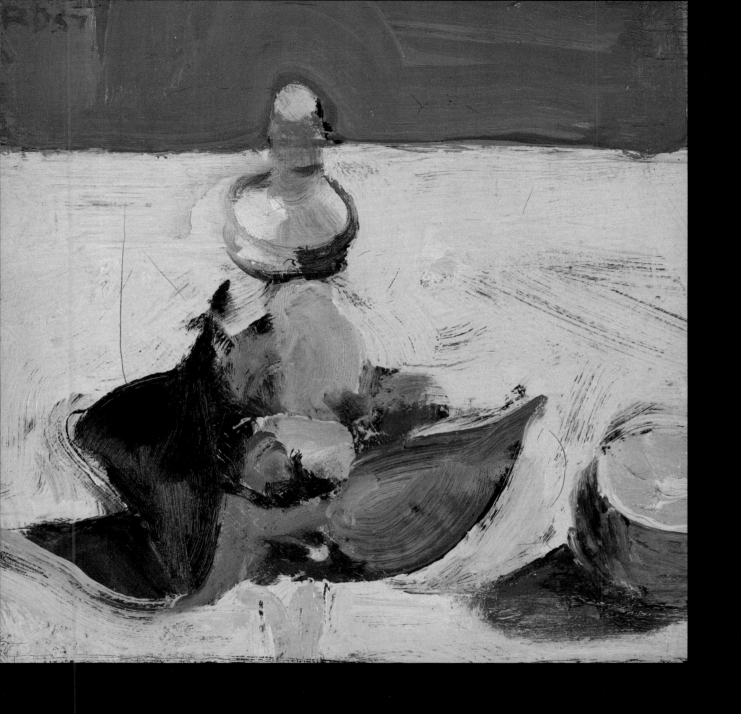

American Still Life

1945 - 1983

American Still Life
1945 - 1983

This publication has been prepared in conjunction with the exhibition **American Still Life 1945–1983** organized by Linda L. Cathcart for the Contemporary Arts Museum, Houston, Texas.

Copyright © 1983 by the Contemporary Arts Museum, 5216 Montrose Boulevard, Houston, Texas 77006-6598

All rights reserved. Printed in the United States of America. No part of this book may be used or reproduced in any manner whatsoever without written permission except in the case of brief quotations embodied in critical articles and reviews. For information address Harper & Row Publishers, Inc., 10 East 53rd Street, New York, New York 10022. Published simultaneously in Canada by Fitzhenry & Whiteside Limited, Toronto.

Library of Congress Card Catalogue Number 83-70899
ISBN 0-936080-12-4 (Contemporary Arts Museum)

Library of Congress Card Catalogue Number 83-47955
ISBN 0-06-430131-1 (Harper & Row)

American Still Life 1945-1983

Linda L. Cathcart

Contemporary Arts Museum, Houston, Texas

in association with

Harper & Row, Publishers, New York,
Cambridge, Philadelphia, San Francisco, London,
Mexico City, São Paulo, Sydney

American Still Life 1945–1983 has been supported in part by a grant from the National Endowment for the Arts, with additional support from the Shell Companies Foundation, Incorporated and Mr. and Mrs. Harris Masterson III.

The catalogue has been funded through the **Contemporary Arts Publication Fund,** established by The Charles Engelhard Foundation in May 1982 with additional support from The Brown Foundation, Inc., Houston, Texas, and The Arch and Stella Rowan Foundation, Inc.

Exhibition Tour

Contemporary Arts Museum
Houston, Texas
September 20–November 20, 1983

Albright-Knox Art Gallery
Buffalo, New York
December 10, 1983–January 15, 1984

Columbus Museum of Art
Columbus, Ohio
April 7–May 20, 1984

Neuberger Museum
State University of New York at Purchase
June 7–September 15, 1984

Portland Art Museum
Portland, Oregon
October 9–December 9, 1984

Cover:
Richard Diebenkorn
Flower and Glass Stopper 1957
Oil on canvas
8¾″ x 8¾″
Collection Mr. and Mrs.
Richard Diebenkorn

TABLE OF CONTENTS

ARTISTS IN THE EXHIBITION

Milton Avery
William Bailey
David Bates
Ed Baynard
Jack Beal
Thomas Hart Benton
Ed Blackburn
Nell Blaine
Troy Brauntuch
Vija Celmins
Robert Colescott
Mary Ann Currier
Richard Diebenkorn
Linda Etcoff
Manny Farber
Eric Fischl
Janet Fish
Audrey Flack
Alice Forman
Jane Freilicher
Albert Eugene Gallatin
Jedd Garet
Gregory Gillespie
Ralph Goings
Morris Graves
Philip Guston
Hans Hofmann
Neil Jenney
Jasper Johns
Alex Katz
Yasuo Kuniyoshi
Gabriel Laderman
John Lees
Alfred Leslie
Roy Lichtenstein

Louisa Matthiasdottir
Nancy Mitchnick
Malcolm Morley
Walter Murch
Catherine Murphy
Alice Neel
Jud Nelson
Claes Oldenburg
Richard Piccolo
Fairfield Porter
Larry Rivers
Harry Roseman
Lucas Samaras
George Segal
Richard Shaw
Charles Sheeler
David Smith
Niles Spencer
Saul Steinberg
Billy Sullivan
Jim Sullivan
Wayne Thiebaud
Sidney Tillim
James Valerio
Andy Warhol
Tom Wesselmann
Paul Wiesenfeld
Donald Roller Wilson
Jane Wilson
Paul Wonner
Albert York
Joe Zucker

\mathcal{S}ENDERS TO THE EXHIBITION

David Bates, Dallas, Texas
John Berggruen, San Francisco, California
The Continental Corporation, New York City
Mr. and Mrs. Richard Diebenkorn
Shelly and Norman Dinhofer, Brooklyn,
 New York
Edward R. Downe, Jr.
James F. Duffy, Jr., Detroit, Michigan
Lyman Field
Ian Glennie, Houston, Texas
Graham Gund
Robert and Doris Hillman
Mr. and Mrs. Edward R. Hudson, Jr.
Jasper Johns
Ivan and Marilynn Karp
Martin Z. Margulies, Miami, Florida
Mrs. Pollard Marsters, Houston, Texas
Susan Pear and Louis K. Meisel
Mr. and Mrs. Morton G. Neumann
Charles E. Pattin, Houston, Texas
Dr. and Mrs. Lawrence Rappaport, Davis,
 California
Mr. and Mrs. Sidney Roseman
Clifford Ross
Secor Investments, Inc.
Candida and Rebecca Smith
Mrs. Muriel Tillim
United Missouri Bank of Kansas City, N.A.
Wellington Management Company/Thorndike,
 Doran, Paine & Lewis Collection
Mr. Nicholas Wilder, New York City
Private Collections

Albright-Knox Art Gallery, Buffalo, New York
Arts Commission of San Francisco, California
Crocker Art Museum, Sacramento, California
Des Moines Art Center, Iowa
The Fort Worth Art Museum, Texas
The Metropolitan Museum of Art, New York City
The Minneapolis Institute of Arts, Minnesota
The James and Mari Michener Collection,
 The Archer M. Huntington Art Gallery,
 The University of Texas at Austin
Nebraska Art Association, Sheldon Memorial
 Art Gallery, University of Nebraska-Lincoln
Neuberger Museum, State University of New
 York at Purchase

The Phillips Collection, Washington, D.C.
San Francisco Museum of Modern Art,
 California
Spencer Museum of Art, The University of
 Kansas, Lawrence
The Toledo Museum of Art, Ohio
Whitney Museum of American Art,
 New York City
Wichita Art Museum, Kansas

Mary Boone Gallery, New York City
Charles Cowles Gallery, New York City
Davis & Langdale Company, Inc., New York City
Delahunty Gallery, Dallas, Texas
Sid Deutsch Gallery, New York City
Fischbach Gallery, New York City
Forum Gallery, New York City
Xavier Fourcade, Inc., New York City
Allan Frumkin Gallery, New York City
The Harcus Gallery, Boston, Massachusetts
Hirschl & Adler Modern, New York City
Nancy Hoffman Gallery, New York City
Sidney Janis Gallery, New York City
Kornblee Gallery, New York City
M. Knoedler & Co., Inc., New York City
Janie C. Lee Gallery, Houston, Texas
Meredith Long & Co., Houston, Texas
Gross McCleaf Gallery, Philadelphia,
 Pennsylvania
David McKee Gallery, New York City
Louis K. Meisel Gallery, New York City
Robert Miller Gallery, New York City
Alexander F. Milliken Inc., New York City
Moody Gallery, Houston, Texas
Oil and Steel Gallery, New York City
The Pace Gallery, New York City
Semaphore Gallery, New York City
Robert Schoelkopf Gallery, New York City
Texas Gallery, Houston, Texas
Edward Thorp Gallery, New York City
Daniel Weinberg Gallery, Los Angeles/
 San Francisco, California

FOREWORD AND ACKNOWLEDGEMENTS

Since its founding in 1948, the goal of the Contemporary Arts Museum has been to present exhibitions of the current time. During the past thirty-five years, the institution has mounted a variety of exhibitions addressing current issues, and this exhibition is part of a continuing series of major exhibitions devoted to traditional topics in American art. *American Still Life 1945–1983* focuses on 104 works by 67 artists, and like other exhibitions in the series, *The Americans: The Landscape*, 1981, and *The Americans: The Collage*, 1982, its purpose is to examine historically important themes and their treatment by contemporary artists.

Many of the artists included in this exhibition have long been associated with various stylistic developments in modern American art, including: Assemblage, Abstract Expressionism, Pop art, Conceptualism and others. Many such as Jack Beal and Gabriel Laderman work to affirm or reaffirm a commitment to this genre in a traditional manner. Others like Neil Jenney and Jasper Johns have actually redefined the notion of what constitutes a still life. The results of these concerns are varied but by their multiplicity demonstrate the many ways of looking at and realizing a theme.

Still life is about the arrangement of common, ordinary and mundane objects. With origins dating to the seventeenth century, still life has remained a strong concept, always yielding itself to fresh interpretation by painters. The simplicity and clarity of subject matter has fascinated many diverse kinds of artists. The potential beauty to be revealed in everyday objects and the painterly possibilities of light and shadow added to the multitude of compositional possibilities have made still life a constantly intriguing subject to painters.

Sculptors have recently come to the still life genre for subject matter and inspiration. Works such as Roy Lichtenstein's 1977 series of three-dimensional painted bronze reliefs of objects on tabletops are revolutionary in concept and artistic quality. Tom Wesselmann's giant, freestanding reliefs of objects usually found on dressing tabletops are also unique interpretations of objects particular to our times.

The iconographic value of objects in modern still life is quite different from that intended in early depictions of objects. Contemporary still life deals both with objects which convey meaning and objects which are of interest for their own formal properties. As of now, there has been no occasion to examine in depth this genre which continues to remain as significant a subject in the work of contemporary artists as it was for those of earlier eras. A clear need for an exhibition on this topic has prompted the organization of *American Still Life 1945–1983*, the first large-scale and historical treatment of the use of this subject matter by contemporary American masters.

This exhibition would not have been realized without the participation and enthusiasm of the artists, their galleries and collectors, the lending museums, and the funding and the participating institutions.

The artists have been most generous with their time in answering questions and tracking down pictures as have the staffs of the galleries. I would like to thank the collectors of still-life works, from the most conventional to the most far-reaching definition of this artistic tradition. This includes the many individuals and museums who have supported this exhibition since its inception and separated themselves from works of great value for such a long period of time. Our heartfelt thanks are devoted to both our old and new friends for their participation and generosity.

I would like to acknowledge the generous financial support for this project provided by both public and private sources. Funds for the organization and implementation of the exhibition have been provided through a significant grant from the National Endowment for the Arts. Other support towards this end has been received from the Shell Companies Foundation, Incorporated, marking the third exhibition in the *Americans* series exhibitions organized by the Contemporary Arts Museum which that foundation has helped support. These organizations have been joined by Mr. and Mrs. Harris Masterson III, whose continued generosity over the years has been of great importance to the Contemporary Arts Museum and to the cultural life of Houston. Accompanying the Houston presentation of the exhibition will be a series of lectures and educational programs made possible by the *Visiting Artist Lecture Series Fund* established by Mr. and Mrs. Fayez Sarofim and Fayez Sarofim and Company.

The catalogue has been funded through the *Contemporary Arts Publication Fund* made possible through the generous and on-going support of The Charles Engelhard Foundation. Established in May 1982, this fund allows the Contemporary Arts Museum to publish scholarly and visually exciting publications to document its exhibitions. The leadership of the Engelhard Foundation has also attracted other support to that fund from The Brown Foundation, Inc., Houston, Texas, and The Arch and Stella Rowan Foundation, Inc. Further, the publication of *American Still Life 1945–1983* has created the opportunity for us to work with Cass Canfield, Jr., of Harper & Row Publishers, Inc., which will be distributing the catalogue.

We are delighted to be joined in this presentation by four important museums and would like to thank the directors and curators of the participating institutions: Robert T. Buck, former Director and Douglas G. Schultz, Acting Director, Albright-Knox Art Gallery, Buffalo, New York; Budd Harris Bishop, Director and E. Jane Connell, Assistant Curator, Columbus Museum of Art, Ohio; Suzanne Delehanty, Director and Lawrence Shopmaker, Assistant Director, Neuberger Museum, State University of New York at Purchase; and Donald Jenkins, Director and Rachel Rosenfield Lafo, Associate Curator, Portland Art Museum, Oregon, who are working with us.

A tremendous amount of support has been offered by the Board of Trustees of the Contemporary Arts Museum for allowing me the essential time away from the Museum to write this catalogue essay. The staff of the Museum has labored many long hours with enthusiasm, insight and support to make *American Still Life 1945–1983* a reality. I am particularly grateful to Emily L. Todd, Curatorial Intern, who with the assistance of Darla Comeaux, Docent Coordinator; Dana Friis-Hansen, Program Coordinator; Sally Gall, former Coordinator of Special Projects; and Jean Story, Research Assistant, compiled the artists' biographies. I am also indebted to Karen Lee Spaulding for her editorial assistance with the catalogue essay. I would like to extend my deep appreciation to Marti Mayo, Curator; Emily Croll, Registrar; Timothy Walters, Publications and Public Information Officer; Mary Cullather and Vicki Bailey, Secretaries; Michael J. Barry, Head Preparator; Clay Henley, Assistant Preparator; and all the other members of the staff who worked tirelessly on this project.

L.L.C.

American Still Life
1945-1983

European and American still-life painting before 1940 has been surveyed and well-documented. The advent of Abstract Expressionism in America in the 1940s, however, virtually eclipsed all other significant art forms. Still life, like portraiture and landscape painting, has since been considered a sideline of the mainstream artistic activity. With its mature beginnings in Europe in the seventeenth century, artists of many persuasions and from many cultures have made still lifes. The still life has continued to reflect the developments of its time. Thus, a survey of still life at any period can provide a good indication of prevailing styles.

Modern still life may not have attracted any particular attention, but it remains a natural choice for artists. The greatest artists of our time have tried their hand at still life, whether sporadically or intensely, producing fresh results from the crossing of styles and the employment of technical achievements gleaned from other investigations.

The laborious technique of still-life painting is perhaps one of the ways it must obviously diverge from the acceptably avant-garde style of Abstract Expressionism and those styles generated from it. But more than a few of the Abstract Expressionists used still life either as a starting point or as a source of inspiration in the early stages of their careers, or even later as a touchstone when theoretical investigations wore thin.

Traditionally the still life has been considered a reflection of joy and humanism; participated in by both the viewer and the creator, it celebrates intimately known things. The choice of subjects has greatly expanded but in modern still-life painting traditional objects such as a vase of flowers, a bowl of fruit, a skull, a mirror a fish are still in evidence. Popular because they are so familiar, they can be reinterpreted in meaningful and emotional ways.

The still life as a subject is the most deliberate in all of art. Still lifes do not exist; they must be arranged by the artist in actuality or the mind, or through the lens of a camera. The act of arranging is indicative of artistic intent. Making still-life pictures, perhaps more than making any other type of painting, puts artists on a common ground that reveals significantly their individual sensibility. Despite virtuosity technique and the seeming unity of presentation all artists are not bound by similar intent. Some are interested in creating mystery through unusual, unexpected juxtapositions; others are interested in translating the everyday. As a genre still life can be humorous, even lowbrow, or it can be symbolically refined, almost spiritual. can be so reduced as to become abstract or so enhanced as to be *trompe l'oeil*. Subject matter however, is the foremost concern while the processes and perceptions differ. The still-life painter mixes observation and invention, intelligence and feeling to relate the real and the ideal so even the affirmation of the ugly can become desirable and acceptable in still life.

A number of artists included in this exhibition are interested in traditional representative painting while others are highly subjective in their treatment of the theme. It is this coexistence which, for many, defeats the notion of a linear development in American modernism. The questioning of this view of progress in art has emerged as dominant in the thinking about this exhibition.

"What has happened to the humble still life?" The answer to that question is that still life remains a concern of artists. It is changed in some aspects but retains some of the traditional characteristics. This essay and the works in the exhibition will illustrate the consistencies, the differences and the breadth of the contemporary American still life. Some of the artists included are specialists of the genre and work within a traditional, conservative interpretation of the subject. More than half of the artists' reputations have been based upon figurative, abstract or landscape pictures. They are included for their contributions to the still-life tradition in both painting and sculpture. A few might come as a complete surprise to many viewers, though the work presented relates in a meaningful way to the individual artist's career as a whole and to the larger tradition.

It is the purpose of this exhibition to survey still life and its place in contemporary art history. Restricted to 104 works by 67 artists, this display attempts to present a fairly comprehensive, although not encyclopedic, look at still life produced in America during approximately the last four decades.

The criteria for the selection were prescribed primarily by two limitations. The first was that all the works included are close to the true definition of still life: that of the *nature morte* or *natura un posa*, wherein inanimate objects are isolated and are in repose and there is no implication of action. Second, that the paintings and sculptures have a currency and vitality attesting to the relevancy of the mode to contemporary artists. The exhibition is not meant merely to survey what is being done but to recognize that there is vital and innovative still life in this half-century which constitutes, for the scholar and observer, contemporary art history.

The history of the still-life tradition is complex, and it is important for the sake of the ideas behind this exhibition to discuss the highlights.[1] Still life has never been just a representation of the facts; it has always reflected daily concerns and attitudes towards life on earth. On Egyptian reliefs, in Greek painting and in later Roman mosaics and frescoes are depictions of ordinary objects such as food and flowers. These were attempts to imitate nature; they were also a reflection of an ordered time and of a life with concern for comforts. Not again until the first half of the fourteenth century does one find in Italian and German painting the same attention given to objects as to the rendering of figures. Christianity began to take into account daily life; so too did art. In the frescoes and paintings of Giotto, for example, there is great curiosity about the world and its objects and the same desire for naturalism as was found in the art of antiquity.

Parallel to the events in Italian painting leading toward pure still life were those taking place in Northern Europe. Secular art was beginning to develop in response to the demands of the merchant class whose patronage of the arts created a market for certain kinds of pictures. The memorable example is Jan van Eyck's well-known portrait of Giovanni Arnolfini and his bride (1434) in which we can see clearly the artist's desire to represent actual daily life complete with the appropriate common objects. Van Eyck included only those objects consistent with the activity portrayed and rendered each faithfully.

Pictorial investigations which reflecte concurrent scientific discoveries during the Renaissance first began to raise questions of s and the ratio of objects to one another and to picture as a whole. Gravity's effect on depicte objects was also acknowledged. The use of obj incorporated in paintings with purposes other than pure still life continued during the fiftee and sixteenth centuries.

In the seventeenth century numerous distinct styles of still-life painting began to emerge in Europe almost simultaneously. In Northern Europe pictures were decorative, m to fool the eye, a style later termed *trompe l'o* These usually displayed food, or they were all gorical *vanitas* or *momento mori* composition whose main subject was the skull—still lifes serving as a reminder of man's mortality. In Dutch pictures each object was important in of itself and was reproduced in painstaking d tail. In Flemish pictures of the same period st life was opulent, sensual and not at all like t Dutch painting. In Southern Europe, Spanish still-life pictures reflected, for the first time, t possibility of selecting and arranging objects their symbolic value rather than merely for t descriptive possibilities; these were made mo mystical and symbolic by the artists' method paint handling. In France still life was ration and measured.

With the revival of easel painting in the seventeenth century, true still-life painti appeared. The most important of these are attributed to Caravaggio who fused previous traditions.[2] His still-life compositions reflect t same expressive monumentality and concern

1. For the definitive study on European still life up to 1940, see Charles Sterling, *Still Life Paintings: From Antiquity to the Twentieth Century*, 2d ed. rev. (New York: Harper & Row, Publishers, Inc., 1981) and for American still life in the period 1801–1939, see William H. Gerdts, *Painters of the Humble Truth: Masterpieces of American Still Life 1801–1939* (Columbia and London: University of Missouri Press, with Philbrook Art Center, Tulsa, Oklahoma, 1981).

2. For more information on Caravaggio's still lifes, see Walter Friedlaender, *Caravaggio Studies* (Princeton, Ne Jersey: Princeton University Press, 1955).

form found in his large, figurative pictures. He interpreted the vitality of forms and he infused his works with a sense of observation. In them the viewer's perspective of the still life is changed from an overview to a profile, eye-level view. The artist's intent is demonstrated by the qualities of his subjects and their arrangement. The ripeness of fruit and the richness of drapery show still life not merely as a vehicle to present the everyday without comment or interference, but as a composition with narrative possibilities and emotional content.

The awakening of both the landscape and still-life genres paralleled the development of the scientific method of inquiry of the seventeenth century. Landscape painting began to refer to actual incidents in nature and artists changed their focus from religious events and portraiture to an attempt to imitate natural things. This interest in, and enthusiasm for, naturalism affected still-life painters who began to give individual qualities to fruit and flowers, just as the landscape artists imparted these qualities to specific, not imagined, settings in nature.

In the eighteenth century in France the painter Chardin transformed the *trompe l'oeil* and decorative still-life tradition by making pictures in which the formal arrangement of objects on a neutral ground was exquisitely presented.[3] Simple and powerful, these pictures were indicative of the rational objectivity of the times. His art was essentially different from Caravaggio's in that it was less poetic and lyrical and more harmonious and cerebral. Chardin presented the still-life genre with its first pictures in which formal concerns took precedence over technical accomplishments. It is Chardin's conservative influence which we are to see most clearly in the works of the first American still-life painters of the late eighteenth through the nineteenth century from the School of Philadelphia—from Charles Willson Peale through William M. Harnett and John Frederick Peto.

At this point in history still life had come to have three aspects: symbolic, descriptive, interpretive. These distinctions within the genre are still valuable and serve to help in the understanding of modern still life.

Although Chardin made a departure from the tradition, there was little else produced in the way of still life in eighteenth-century Europe which was innovative. Artists active in the nineteenth century, Corot, Delacroix, Gauguin, and Fantin-Latour, for example, continued to use still life in the romantic tradition established by Caravaggio. Others, like Manet, produced paintings of such realism that they had a profound effect on the subsequent still lifes of Cézanne and Goya made at the end of the century.

3. For more information on Chardin's still lifes, see Pierre Rosenberg, *Chardin 1699–1779* (Bloomington, Indiana: The Cleveland Museum of Art, Ohio, in cooperation with Indiana University Press, 1979) and Gabriel Weisberg, *Chardin and the Still-Life Tradition in France* (Bloomington, Indiana: The Cleveland Museum of Art, in cooperation with Indiana University Press, 1979).

Cézanne and Goya each found still life a vehicle for pictorial possibilities. Cézanne's was a measured, orderly and subjective investigation and, because of his proximity to the Impressionists, was concerned with the qualities of light and volume. On the other hand, Goya made expressive and spontaneous pictures in which the paint application appears freely executed and the arrangement of objects is casual and natural when compared to Cézanne's artful and careful, almost noble, treatment of fruit and crockery. Cézanne addressed plastic problems in all of his art. In Manet's work he observed a variety of brushwork, evocative atmosphere and abstraction. He chose, however, to emphasize volume and often used still life as his means for the study of the three-dimensional object rendered in two dimensions. The tension in his pictures was created by the dense placement of objects which defied gravity. His pictures opened the way for the modern spirit of painting found in the still lifes of the Cubists.

At the beginning of the twentieth century, in Cubism, modern still life makes one of its most important appearances. Picasso and Braque drew upon the complex compositions of humble and bourgeois objects in Cézanne's paintings for their own inspiration. Picasso's still lifes clearly indicate that his concerns were, in fact, not with abstraction but rather with the portrayal of reality. He used Cubist painting and sculpture techniques for their qualities of rendering patterned objects in two-dimensional compositions which did not disguise, but rather emphasized, the reality of the forms. Braque also attracted to still life as a patterning device but he chose a thinner application of paint. As a result, his canvases have a flatter, more mosaic like aspect with less emphasis on volume. Inspired by Cézanne, both artists introduced a monumentality to still-life subjects while presenting harmonious compositions which suggested the metamorphosis of objects into other forms and the potential for intellectual and aesthetic analysis.

The Fauves, also active at the beginning of the twentieth century, were concerned with bold, rhythmical application of color. They were led by Matisse who made some of the most beautiful and significant still lifes of the period. Matisse's still lifes are simple and original and decidedly domestic. They are dominated by single patches of color that create forms, an idea inherited from the Cubists; his use of color, however, was unadulterated and direct. Cézanne and Matisse were to be crucial to the history of still life because of their original and innovative use of drawing and choice of subject. Other European artists from the early twentieth century such as de Chirico, Léger, Morandi, Seurat and Van G

adapted the still life to their own individual ends, and their works have been recognized as important by contemporary artists as well.[4] Another stylistic influence, not often connected to still life, but nonetheless important to its history, was Dada and Surrealist sculpture, for example, the works of Meret Oppenheim and Man Ray.

Generally speaking, American still-life painting began in the late eighteenth and early nineteenth centuries and made its first appearance in a reserved and classical manner. As the tradition developed in this country, the pictures became bold and cluttered and the world represented became more democratic, energetic and less contemplative. This look parallels the adventurous and daring nature of the culture in which it was produced.

In her book, *American Painting of the Nineteenth Century*, Barbara Novak has written on the subject of the still life as it came into its own in America in the nineteenth century. She described still life not merely as a repository of information about a materialistic culture, but as the consummate identity of painting at that time in this country. Novak wrote, "Much American art of the late eighteenth century and of the nineteenth century can in fact be seen as still life, whether a portrait by Copley or a landscape by Lane."[5]

In the eighteenth-century portrait paintings of John Singleton Copley and Charles Willson Peale are objects, vases of flowers and bowls of fruit, included to add symbolic meaning. These objects were used to tell the viewer facts about the sitter. A bowl of fruit might, for instance, be an indication of an abundance of children. Copley was remarkable not only for his ability to paint skillfully but also for his artful use of symbolism. Peale's arrangments of objects present the viewer with solid, formal, simple, yet meaningful still lifes. One of Charles Willson Peale's sons, Raphaelle, is recorded as America's first still-life painter. His pictures are illusionistic, life-sized descriptions of food and tableware. These paintings are, as are all the paintings of that period, neoclassical in their formal approach and intent.

The works of primitive or naive artists and artisans, who often used as their subjects formal arrangements of food and fruit, contributed to the development of pure American still life and are still a source of inspiration for contemporary painters and sculptors.

In the mid-eighteenth century, new life for the form appeared primarily in fruit and flower paintings, reflecting the naturalism of Dutch pictorial styles of the late seventeenth and early eighteenth centuries. Concurrent with the writings of John Ruskin, the still life began to appear within other kinds of paintings, occasionally in natural settings.

4. For more information on Morandi's still lifes, see essays by Joan M. Lukach and Kenneth Baker in *Giorgio Morandi* (Des Moines, Iowa: Des Moines Art Center, 1981).

5. Barbara Novak, *American Painting of the Nineteenth Century* (New York: Harper & Row, Publishers, Inc., 1979), p. 221.

Later, in the nineteenth century, an interest in science and nature provided inspiration for still life. Botanical and floral subjects were common, and the specific thing was of interest. At a time in American history when painters felt that observation of all of God's creations could provide clues to the understanding of the inner order of the universe, this thinking was extended to an interest in portraying nature's variety and order and in attempts to identify specific kinds of natural phenomena. The character of natural phenomena and the distinction of one thing from another in nature were analyzed. Variety, surprise and irregularity are the natural qualities which were sought in these pictures and are well illustrated by the flower paintings of Martin Johnson Heade made in the late 1800s.

Novak sees American realism as a conceptual realism "where the presentation of the subject is controlled by a knowledge of its properties that is the tactile and intellectual rather than optical or perceptual."[6] She feels this tradition, which opposes the one to which Chardin and Cézanne contributed, typifies the attitudes prevalent when Charles Willson Peale began to paint and which continued to dominate during that century and throughout the time of the pictures of Harnett.[7]

While early American painters consis tently ennobled the still life, artists such as Harnett and Peto reverted to the European tr tion of the decorative style. But just as all American artists can be seen to manipulate h tory and turn it to their own ends, these two artists introduced a new feeling of sheer plea sure in things. In a significant break with tra tion, they introduced, as subject matter, perso history and the concept of the artist as collect Made in the late Victorian period, a time of g expansion, there is a materialistic exuberanc about these works which glorify the private d filled with old precious possessions. The influ ence of the seventeenth-century European m ters who valued scientific observation as well the more measurable value of costly objects i reflected in the paintings of this period. The light and freshness of nature are gone—the organic, free-flowing composition is replaced an almost maudlin, sentimental design with plications of mortality.

The tendencies in American realism manifested by Harnett and Peto can now be identified as significantly different.[8] Harnett valued for his technical skills, for his abilitie produce *trompe l'oeil* illusion and for his finit and precise renderings. The nineteenth-centu still-life *trompe l'oeil* painting was "a culmina tion of the desire to define the outer world, at same time that it initiated the new century's amination of pure artistic form and process."[9]

6. Novak, *American Painting of the Nineteenth Century*, p. 223.

7. Ibid., pp. 221–23.

8. For more information on Harnett and Peto, see Alfred Frankenstein, *After the Hunt: William Harnett and Othe American Still Life Painters, 1870–1900*, 2d ed. rev. (Ber ley, Los Angeles and London: University of California Pr 1975) and John Wilmerding, *Important Information Insi The Art of John F. Peto and the Idea of Still-Life Painting Nineteenth-Century America* (Washington, D.C.: Nationa Gallery of Art, 1983).

9. John Wilmerding, *American Art* (Middlesex, England New York: Penguin Books Ltd., 1976), p. 143.

Peto, on the other hand (who was a friend and follower of Harnett), had a rawer, rougher style, mysterious and non-illusionistic in intent. His unique qualities were those by which he explored the formal properties of his subjects. His work, like Chardin's, was guided by the belief that simple objects carefully observed possess qualities of expressiveness. His canvases were composed with all the forms arranged around one another, but it was not his intention to give life to these forms. His work, along with that of Chardin, shares a delight in purely formal painting concerns. Both Harnett and Peto made contributions that were of importance to later artists.

John Wilmerding wrote that the optimistic, democratic aspects of American life are embodied in Harnett's work, as well as the quality of hermetic isolation and specificity of objects identified by labels or signs with words faithfully reproduced.[10] This adaptation of lettering as a formal device will be seen later in Stuart Davis' work of the 1920s. Peto's mystery and use of light took him into a realism where formal compositional concerns were combined with an infusion of light absorbed and reflected by things rendered.

American still life of the first half of the twentieth century is virtually impossible to discuss chronologically or in terms of stylistic development because of the complexity of influences. Two schools of thought were important to the continuation of still life. One was that of the artists who felt it necessary to hold to traditional kinds of art-making; they felt still life was immune to the radical stylistic changes being wrought by the European modernists and their admirers in America. On the other hand, the most progressive of the American artists who painted all kinds of subjects—including still lifes—thought that this kind of painting could be subjected to new interpretation like all others.

The early 1900s saw the formation of the socially and morally purposeful Ash Can School. Still life was seen in opposition to their ideas and consequently not deemed important as subject matter. The other path available to modern American painters was that laid by the work of Cézanne and Matisse and followed by the Precisionists and the Synchromists. The American interpretation of Cubism as well as Marsden Hartley's version of Fauvism and Arthur B. Dove's Cubist-influenced collages, for all their adherence to European modernism and ideas, finally return to a mature, principally American vision. Their pictures were defined by sharply limited space, hardness of style, balance of parts, an accuracy of rendering and a fascination with man-made objects and machines.

10. Wilmerding, *Important Information Inside: The Art of John F. Peto and the Idea of Still-Life Painting in Nineteenth-Century America.*

Preceding the arrival of European abstract artists to America in the 1940s, representational works in this country had been largely dictated by Dutch, Italian and German painting. Many American painters of the nineteenth century went to London, Paris and Düsseldorf to study the works of the Old Masters and with the teachers of the academies. In American painting, as in the history of European painting, the develoment of still life is a substory of the development of realism and is reflective of daily reality as formed by the political, social, economic and religious concerns of the times.

After the challenge of European abstraction in the form of Cubism, American artists thought and wrote about the qualities of realism. Niles Spencer wrote:

> The term Realist, as it is applied to the contemporary painting, has acquired a number of contradictory associations. These should be made clear if the aims of many present-day artists are to be understood. This note can only hint briefly at one of them.
>
> There is realism in the work of the abstract artists, Picasso, for example, is always concerned with some basic reality. . . . The deeper meanings of nature can only be captured in painting through disciplined form and design. The visual recognizability is actually irrelevant. It may be there or not.
>
> Realism is a pretty much battered-around word, but its true meaning has always been part of the modern artist's concern, and if he is to realize his purpose, it always will be.[11]

This statement, like numerous others by arti of the time, seems to conclude that intention subject determine the resultant degree of realism.

In American art, the events which oc curred at and around the Armory Show of 19 provided the turning points for the evolution the American avant-garde. The art of the Europeans—Picasso, Braque and Duchamp— was seen and absorbed. Their modernist conc were introduced into the work of artists who were making genre paintings.

Around 1915 the American Synchron and Precisionists examined the ideas of Cubi creating still-life paintings in which objects v reduced to the basic elements of the cylinder, sphere and the cone. The result was still-life paintings not at all reminiscent of European Cubism since the American version introduce man-made and industrial objects. Particularl suited to the Precisionists' rendering of shar[edged forms in still-life compositions were th Cubist techniques of picture-making and thei dynamic compositional devices such as the ra cal tilting of the tabletop surface. The collage produced by American artists beginning in tl 1920s may, in fact, signal the beginnings of t modern American still life. It can be argued 1 the use of collage for artists like Stuart Davis was a device to make an original statement about the still-life mode rather than a way of imitating Cubist works. His works are compo tionally open and casual, as opposed to the de

11. Richard B. Freeman, *Niles Spencer* (Lexington, Kentucky: University of Kentucky, 1965), p. 11.

and linear qualities found in the late Cubist works of the European masters. Davis felt that subject matter was over-emphasized. By 1918 what mattered to him most was pictorial organization. Searching for a logical, structural concept by which to make paintings, he observed the work of the Cubists and, by 1928, he painted what was to be for him an important series of pictures entitled *Eggbeater*. It was through this series of paintings that Davis:

> . . . got away from naturalistic forms. I invented these geometrical forms . . . I focused on the logical elements. They became the foremost interest and the immediate and accidental aspects of the still life took second place.[12]

Noteworthy also in the period of the 1920s is Gerald Murphy, an artist who not only made few still lifes, but who made few pictures all together. Murphy's still lifes were like those of Davis in that they were influenced by Cubism and were composed of flattened planes and were not abstracted images. What distinguishes them is the monumentality, in both size and scale, of the common objects that are their subject. Until this time in history, almost every object depicted had been close in scale with reality. It is possible to see in the work of the 1920s the visual link between the Cubists' still lifes and those produced fifty years later by the Pop artists. Specifically, Davis' combination of the American theme with the Cubist device of the object isolated and transformed and Murphy's common object in monumental scale prefigure in particular the work of Tom Wesselmann and Claes Oldenburg.

It is difficult to isolate an interest in still life in the following decades of the 1930s and 1940s. Magic Realism and the New Objectivity were styles typified by static compositions in airless space and a silent atmosphere and were usually devoted to figuration. In addition to the more eccentric styles of realism prevalent at the time, painters like Thomas Hart Benton espoused a philosophy of art termed Regionalism in which the rural scene became symbolic of the energy and uniqueness of the American experience. The Europeans had introduced Dada, Surrealism and Automatism into the vocabularies of the American artists, and once again artists whose subjects were particularly American had the choice of remaining academic or adopting the avant-garde stance.

Then came Abstract Expressionism, the first major painting style to be thought of as completely American in development and in method. Born of many parents, Abstract Expressionism combined the playfulness of the Dadaists and the subconscious markings of the Automatists and the Surrealists with the Regionalists' desire for the monumental subject. Abstract Expressionism introduced possibilities for scale and paint application which were to mark all other art made afterwards.

12. James Johnson Sweeney, *Stuart Davis* (New York: The Museum of Modern Art, 1945), p. 16.

The importance of the still life was reiterated by certain New York artists of the 1950s and 1960s. Their object-oriented painting and sculpture was made in defiance of abstraction as a subject for art. Gestural painting done in the 1950s and early 1960s, however, provided the stylistic basis for both abstract and representational work. By the mid-1960s, it was apparent that other possibilities such as hard-edge, Pop and color field painting techniques were to offer valid pictorial alternatives. During this period the artists who produced still lifes were primarily painting landscapes, figures or interiors.

It has always been observed that American artists, whatever the subject of their works, have a penchant for the real, the physical and the practical. This realist tradition which produces the majority of the still-life painters is an affirming one. It is a tradition which once seemed in opposition to the exhaustive despair of modern abstraction. The art which concerns itself with daily life and with objects is actually concerned with life itself, while abstraction is often characterized as having to do with pure emotion. But it is not always the still-life artists' intention only to render forms faithfully. It is often their aspiration to examine and emphasize life in all its aspects and this is where abstraction and realism come close together.

The symbolic possibilities of still life seem most surely embodied in the work of the Pop artists and those whose works are object-oriented. These works are most concerned with message and narrative and they choose object be the vehicles for content. A second group of artists create still lifes typified by description the subject, by scientific and technical accura of depiction. In this group some artists extend the tradition of academic painting in which of jects are secondary to formal concerns. Others use the descriptive mode adding symbolic or n rative aspects to their works. Lastly, there are those painters whose still lifes can be conside interpretative. Their careers paralleled the de velopments in abstract painting of the 1950s; their work clearly bears the marks of Abstrac Expressionism. For them the subject is describ in terms of free brushwork, thick paint and be color and the large-scale canvas.

Pop art has been almost exclusively treated as a style which came into being in di response to, or even in opposition to, the abst styles so prevalent in the 1960s. We know, how ever, that Pop imagery is stylistically related the works of Stuart Davis and, even further back, to Harnett and Peto in its use of comme cial and literary subjects. For Pop artists, still life is not genre painting. The things seen in their pictures are deliberately isolated for perusal. However, since the objects are genera common and mundane, they are clearly ident able. This identification is sometimes made u easy by the Pop artists' stylization of the obje

Furthermore, the Pop sculptors often contradict the physical properties of an object while making art. These works pose an interesting problem. Most still life has dealt in objects that occur in nature, common to all cultures at all times, such as food and flowers. These new pictures take for subjects things which will some day seem nostalgic. For example, the appearances of the television and the telephone will alter with technological advances, and the question then will be whether certain pictures will cease to have meaning when the objects in them become meaningless.

It is the Pop and New Image artists who extend the symbolic role of the still life in contemporary art. Not traditionally considered with the genre, Andy Warhol's works are prime examples of the symbolic still life. In his works Warhol isolates an object to be mechanically represented on canvas. In many cases that object is reproduced several times. This serial representation has the effect of emphasizing the commonness of the object. Warhol's intent in making these pictures was to focus the viewer's attention on one thing which had been seen presumably many times before but had never been considered outside of its context. Warhol's response to the symbolic possibilities of the objects he paints may be part of his purpose, but his work seems also a response to the formal possibilities of making painting in the post-Abstract Expressionist era. For example, his series of paintings titled *Still Life* depicts a hammer and sickle in various sizes and color combinations of black and white or red and black; simple shapes mechanically, yet lushly, reproduced unexpectedly refer to gestural painting. Strictly speaking, these are not still lifes of the usual order. This particular selection of ordinary objects, labeled with their brand names, and their seemingly casual arrangement has potent political associations. While all of Warhol's subjects—whether flowers, Brillo boxes, soup cans, skulls, or garden tools—appear at first to be ordinary, they are all chosen specifically for their recognizable and latent symbolic content.[13]

Tom Wesselmann began making still lifes as elements of composition in his *Great American Nude* series. This tradition of still life within portraiture has a history which dates back to Flemish painting in the fifteenth century. In order to create an art which was absolutely his own, Wesselmann sorted through the materials he had collected for collages and began to attach actual objects to the canvases. "These cultural objects were not especially significant to him, however, until they were isolated and their super-reality potential anticipated."[14] This art was to have two important effects. First, stylized objects such as televisions and radios and complicated subjects such as kitchens could serve as indications of the artist's society and his place within that society. Second, was the consideration of still life as a serious subject for sculpture.

13. Because it is not possible in a publication of this size to discuss each artist, I have made brief entries intended to describe the role of still life within each artist's oeuvre. These are found with each artist's biography beginning on page 120.

14. Slim Stealingworth, *Tom Wesselmann* (New York: Abbeville Press, Inc., 1980), p. 25.

Claes Oldenburg is another artist who was interested in reducing familiar objects into simple emblematic shapes, often using a contradiction in scale or material as contrast to the "real-life" presence of a chosen subject. His early works exhibited in a storefront in 1961 consisted of articles of clothing and displays of breads, cakes, pies, meats and other foods, all made of plaster, that were set upon counters creating a real context for these sculptural still lifes. Oldenburg also organized Happenings in which everyday objects became more than props; they became the focus of the actions. The works were, as the artist said, about "how it feels to be alive."[15] How it feels to be alive may be the essence of all still life. Objects imply humanity. The placement of forms describes our daily activities. Objects rendered in still life do not attempt to conceal themselves, rather they focus our attention on ourselves and thus our lives. Oldenburg's art seeks to find "the poetry of everywhere."[16]

Lucas Samaras' extensive body of work is largely based on personal narrative. A series of "breakfasts" and "dinners" made between 1960 and 1964 are most in keeping with traditional still life. These pieces are three-dimensional sculptures which depict in actual scale a place-setting for a table. The meal consists of pins, cotton, wool and mirrors, among other things.

The symbolic and erotic properties of food suggested to him transformation and metamorphosis. The depiction of meals has a tradi which started in the Netherlands in the mid-sixteenth century with Dutch banquet painti which were intended to convey certain allego-ries. Through the meal sculptures Samaras a ludes to greed, beauty and mortality.

The influence of Surrealism is clearly found in the work of Samaras and perhaps les obviously in the seemingly benign works of Oldenburg. The Surrealists' fascination with threatening and ludicrous transformations an juxtapositions was often heightened by their of the most stubbornly obvious objects which they forced into other roles. Meret Oppenheir teacup lined with fur and Man Ray's iron wit tacks on its surface are the precursors for con temporary still-life sculpture which almost al ways focuses on food, household objects or domestic scenes and environments.

Roy Lichtenstein, like other Pop artis makes still lifes in two and three dimensions. The paintings can be straightfoward arrange ments of fruit, flowers and glassware on table tops or more complicated *trompe l'oeil* depicti calling on Picasso, Matisse and Harnett amor others, as sources. The sculptures, inspired by his paintings, are three-dimensional forms ca ried out logically into shallow space according Cubist principles. Lichtenstein has created paintings and sculptures that are measured, classical and balanced. Unlike in Warhol's works, the objects in Lichtenstein's still lifes not specifically symbolic; rather he has create method whereby he can symbolically refer to tire stylistic movements of recent art history.

15. Ellen H. Johnson, *Claes Oldenburg* (Middlesex, England and Baltimore, Maryland: Penguin Books Ltd., 1971), p. 19.

16. Ibid., p. 20.

17. For more information on Lichtenstein's still lifes, see Jack Cowart, *Roy Lichtenstein 1970–1980* (New York: Hudson Hills Press, Inc., in association with The Saint L Art Museum, Missouri, 1981).

In Neil Jenney's paintings the objects, figures and landscapes are defined by their functions. Each picture is given a narrative by the use of an integral painted caption which appears on the bottom edge of the frame. In *Paint and Painted* (1970), there is a paint tray and a roller. Traditional still lifes have often included the tools of the artist's trade. The tools might have been used to create the images, or at least the background of the pictures, but now they are at rest, and the words on the frame give us the understanding of what Jenney wants this picture to be. It is, of course, a still life. The objects are still—they have been composed—not beforehand, but by imagination.

Ed Blackburn is an artist who has recently taken still-life sculpture as his subject. His life-size tableaux include one with a real table on which rests a plaster pitcher and four pieces of plaster fruit—the typical still life, except that the objects are colored in grisaille. Behind the table a square of green canvas tacked to the wall holds two gray images—a baseball player and Edward Kennedy and Jimmy Carter shaking hands in a crowd scene—which appear to have been taken from some source such as a newspaper or magazine. There is a third image which is a picture postcard of a Cubist still life by Picasso. In this work, Blackburn has juxtaposed three kinds of still life—the Cubist, the academic and the "stilled"-life portraits from the newspaper.

Mixing media and cross-referencing ideas as well as paying homage to earlier art are qualities shared by contemporary artists whose concerns are for the real and for the popular or common culture. The works made by George Segal have always kept to life-scale. The plaster cast figures for which he is best known have often occupied a kind of tableau setting, implying an interior. From observation of Cézanne's paintings of tabletop still lifes, Segal has recently produced a group of sculptures which depend upon the wall for support. Titled *Cézanne Still Life* the painted plaster, wood and metal sculptures are remarkable for their ability to transform the two dimensional into three dimensions. The irony, of course, is that the original objects were naturally three dimensional—but, not as Cézanne's composition would lead one to believe. Yet here in Segal's sculpture, they appear as Cézanne would have them. Segal recreates what was there in three dimensions before it was made into a painting. He, however, has made them through, the eyes of Cézanne so that they are distorted and exaggerated.

The single object alone or multiplied, or the stylization of a few very common subjects by the Pop artists, gave to the appearance of the still life new possibilities. Unlike in traditional still life, where concern was for the well-crafted picture in which reality was transferred onto canvas and in which light illuminated the shapes and textures of the objects, these artists make almost no reference whatsoever to light in their work. The reality they represent is not more or less than that which the academically-oriented painters seek, but a different one. Closer to the perceptions of people whose world is informed by

second-generation images, these artists, in their vision and choice of objects, have imbued still life with a freshness, clarity and potency uniquely American. Through the investigation of the symbolic in still life, seen specifically in the work of the Pop artists, it is evident that representation is not an essential ingredient for still life but reality as subject matter is. However, generally speaking, American art since the nineteenth century has been typified by a desire to observe life accurately. The descriptive style has been adopted by two types of realists: the photo-realists, who depend on the use of the camera to compose and who use other mechanical means to reproduce and heighten their images and those whose interest is in academic depiction which depends on technical accuracy. Both rely upon truth to subject matter for character.

The photo-realists, super-realists, hyper-realists and the numerous other artists of this type have been guided by their desire to depict their surroundings with exactitude. It has been mistakenly assumed that a somewhat faithful reproduction of a subject has been enough to classify artists under one of these headings. They are indeed highly individual painters and seem only to be linked finally in general terms. What kinds of still life do we see portrayed by these descriptive realists? Their subjects are identifiably American, familiar and ordinary—but never cute or nostalgic. For each the choice of subject is widely varied, and the manner of relating their subjects is even further apart. Concerned with making paintings which have universal meaning, Audrey Flack works in super- or hyper-realist style, almost entirely within the still-life

genre. During the 1960s she painted religious subjects from art-historical references. In the next decade she painted large canvases filled with objects and bordered by thick gray bands paint. Filled with disparate objects, highly colored and voluptuous, each with a personal meaning, these still lifes often have mirrored surfaces for their grounds which serve to obscure a reading of the subjects. The intense depiction of each object—fruit, flowers, playing cards, cosmetics photographs—seems at first to be an effort to make each look as real as possible but in the end, the result is an overall surface quality wherein each object seems more the same than different. The works are made in the tradition the Dutch *vanitas* paintings: the juxtaposition objects, while symbolizing life on earth, transient pleasures and fleeting beauty, also suggest death and decline.

Ralph Goings is an artist who has been clearly connected to photo-realism. His pictures of urban landscapes, cars, trucks and diners are made by using a photograph as the source and basis for the final work. He has also devoted a group of pictures to the arrangements of condiments seen in diners. These are pictures of countertops in which catsup bottle, napkin dispenser and salt shaker are each rendered in almost true scale. These objects epitomize the ordinary and are without identity other than being clearly American in derivation.

Janet Fish is one of America's best-known contemporary still-life painters. Her large-scale canvases are filled with objects which reflect light—glassware, vases, bowls filled with fruit, liquids, flowers and fish. That light which streams in from an adjacent window, pushing through each object so that it is infused with

glowing color, is the subject of the paintings. The arrangements in Fish's works can be contrived (a grouping of Tanqueray bottles or catsup bottles), but visually there is nothing forced about the objects' relationships one to another. Fish has long been known for her virtuoso skills in rendering reflective surfaces. Recently, however, her compositions include more variety: groupings, in a more traditional still-life manner, of clams and lobsters, for example. Thus she creates for herself situations which demand careful observation of both naturally and artificially lit atmospheres.

Still-life picture-making can be used towards a variety of ends and there are those artists who make exact representation their main concern. The works of William Bailey are almost always still life, although occasionally he makes a portrait or a figurative work. Each of these medium- to large-scale canvases is horizontal in format and depicts a table—usually only the uppermost part, sometimes only the surface—seen at eye level. Upon these surfaces have been arranged groupings of vessels: cups, vases, pitchers, crocks, bowls, mugs and pots. The background and tables are usually monochromatic, brown or green, and the crockery is, in contrast, beige, white and often white with blue trim. Bailey purposely juxtaposes fine china with that of poor or humble quality. His arrangements, made not in the studio, but in the mind, suggest a quiet dialogue between elements. Meticulously painted, yet clearly not concerned with *trompe l'oeil*, these pictures are symphonies of subtle light, shadow and color. Bailey is heir to the traditions of Chardin and Morandi.

Jack Beal and Alfred Leslie seldom devote themselves to painting still lifes, but when they do, their powerful rendition of objects imparts to their work a drama rarely encountered in the still lifes of the other realists. Interested in and committed to confrontation and persua-sion, Beal and Leslie choose their subject matter accordingly. Beal's still lifes with fruit and plants are more traditional than Leslie's television and sneakers but the resultant works share a mysterious and isolated quality.

The descriptive kind of still life chooses between opulence and sparsity. This can be seen in the works of Flack and those of Goings or Bailey. Contemporary American realists seem not to insist on the individuality of each object but rather on some sort of essential knowledge from observation. What the artist knows the thing to be is the quality that seems to dominate these pictures in all styles. Thus these pictures seem not to celebrate the very subject matter which is their origin. The contemporary American artist's knowledge of the possibilities for modern painting dominates at this time and the investigations of space, boundary, surface, plane, color and scale, as well as the subject, are the elements which determine the painting's appearance.

It would be well to remember that while it is taken for granted that realists paint subjects which are dependent upon people, places and objects, Abstract Expressionists were not, in fact, painting pure emotion, but were painting from subject matter as well. There are few examples of still-life paintings from the first generation of Abstract Expressionists. Both abstract and figurative artists like Richard Diebenkorn, Jane Freilicher, Philip Guston, Alex Katz and Fairfield Porter made use of abstract techniques for their still-life paintings. What painters who began to work in the 1950s learned from that style was by painting green where one perceived foliage and blue for the sky and brown in the

area covered by the tabletop, their pictures could eliminate the need for preparatory drawing; thus realism could have another look. The spontaneity and immediacy of this strengthened the impact of the subject's qualities of visual organization.

It is remarkable to note in this context a phenomenon which occurred in the work of the so-called Bay Area painters who lived and worked in San Francisco in the 1940s and 1950s. These artists, among them Diebenkorn, began to paint as mature artists in abstract styles and switched to a figurative mode. Their work was characterized by freedom of philosophical reflection and a mood of general romanticism that was somewhat expressionistic. The figurative pictures are of interest because the isolation of their images is similar to the concept of composing in still life and, even further, often incorporate the window behind the subject as is commonly found in still-life paintings.

In 1956 after a series of successful abstract paintings, Diebenkorn made a switch to figurative painting with the making of a small "messy still life."[18] Because of a desire to regain control over what he felt to be an explosive painting technique, Diebenkorn observed the accumulated clutter on a studio tabletop as a possible subject for a painting. Although his abstractions were inspired by landscapes, the still lifes gave him something which abstraction lacked— something tangible to work with. He felt—and

this is in direct contradiction to those who see still life's only virtue lying in its creator's technical abilities—making subsequent still-life paintings freed him from "performance."[19]

In Diebenkorn's works, the tabletops are tilted to confuse foreground and background readings. This device is attributed to Diebenkorn's interest in Matisse's works which draw upon Islamic painting for inspiration as well as his own love of Persian and Indian miniatures which use this convention. Because the situating of objects for composition is an actual task, their subjection to gravity-defying positioning provides a contradictory stance to the notion that these objects are existing in the real world no matter how realistically they are rendered. The knowledge of Abstract Expressionism's possibilities combined by Diebenkorn with the realistic subject matter produces a picture with what Gerald Nordland terms "a compelling sense of immediacy," suggested both by its composition and the techniques of brushwork.[20]

Fairfield Porter thought "that ideas have no place in art, or at any rate that they have a separate life of their own in art, no autonomy that might siphon off part of the 'reality' of the ensemble."[21] Porter felt, unlike many others included in the modern still-life tradition, that the precepts of modern picture structure were not to be found in Cézanne but rather in Vuillard because he was a more "orderly" painter. He believed in the orderliness of nature and, therefore

18. Robert T. Buck, Jr., Linda L. Cathcart, Gerald Nordland and Maurice Tuchman, *Richard Diebenkorn: Paintings and Drawings, 1943–1976* (Buffalo, New York: Albright-Knox Art Gallery, 1979), p. 26. The essay by Gerald Nordland deals extensively with Diebenkorn's still lifes.

19. Ibid., p. 27.

20. Ibid.

21. John Ashbery and Kenworth Moffett, *Fairfield Porter (1907–1975): Realist Painter in an Age of Abstraction* (Boston, Massachusetts: Museum of Fine Art, 1982), p. 9

in its usefulness as a subject for painting. Kenworth Moffett has written "that Porter often made the point that there is no essential difference between abstract and representational art, and that each is 'real' or has 'presence' in a different way."[22] This seems to typify the explanation given by artists of the same generation as the first Abstract Expressionists for their resistance to making abstract or completely abstract paintings. Porter tried to avoid the setup or prearranged composition in his pictures so he, like Freilicher and Katz who chose still-life subjects, often avoided the purest still-life traditions by including some furniture, an interior or a window in his compositions.

Freilicher and Katz were friends and contemporaries of Porter's, and he wrote thoughtfully and revealingly about Freilicher's work:

> . . . when she has to choose between the life of the painting and the rules of construction, she decides to let the rules go. The articulation of some of the figures is impossible and awkward, and though this is a fault, it is a smaller fault than murder.[23]

Although he is discussing her figurative pictures, Porter's remarks address themselves to the issue of abstraction versus reality in picture-making, and further they apply to her renderings of the objects found in her still-life paintings. Rather than deny a beloved object for lack of interest in the technique necessary to render it most truthfully, Freilicher keeps the object and reproduces it economically and beautifully by means of color and shape rather than line and chiaroscuro.

Katz's work bears the marks of Abstract Expressionism in his use of large scale and size, as well as the use of gestural color and form to stand for the subject rather than for specific representation. Katz, like Freilicher and Porter, found he liked to work from nature where he felt art could be more humanized. His work also belongs somewhat to the Pop art tradition but Katz does not use images from popular culture—one finds no signs or brand names in his work. This is because he is mostly a figurative painter and his still lifes are a by-product of this concern. He does, however, use stylized images and ones which are recognizable. Katz's use of "accurate rendering, understatement of interpretation, tight painting, and 'the big picture'," allowed him to make a representational art which could equal abstraction.[24]

H. H. Arnason noted in 1962 that Philip Guston, despite his bout with abstract painting, had always been a figurative artist.

> It might well be argued that he has never been an abstractionist, but has always been involved with subject painting. Whether the subjects will ever again be representations of objective nature will probably depend upon whether he can ever again find a reason for painting a figure or a landscape.[25]

22. Ibid., p. 29.

23. Ibid., p. 20.

24. Irving Sandler, *Alex Katz* (New York: Harry N. Abrams, Inc., 1979), p. 60.

25. H. H. Arnason, *Philip Guston* (New York: The Solomon R. Guggenheim Museum, 1962), p. 36.

Beginning in about 1968, Guston painted small pictures of single objects—a shoe, a lamp, a book, a clock. Then came the studio interior paintings in which things—a can stuffed with stiff upright brushes, a clock with one hand, a single bare light bulb, a cigarette, a liquor bottle—were depicted in sinister, symbolic still lifes. Guston himself related this about using literal imagery:

> I tussle with this all the time. . . . I am puzzled all the time by representation or not, the literal image and the non-objective; there is no such thing as non-objective art. Everything has an object, has a figure.[26]

He went on to say that there had to be something there for the picture to work—that it had to be concrete and have a life of its own beyond merely representing something and being satisfactory compositionally as a painting. His subsequent canvases were filled with figures and still lifes and blended both abstract painting techniques with highly charged and personal subject matter.

The example of Guston makes it clear that it would be an over-simplification to state that all modern American still life fits neatly into three categories. Many artists share the qualities, methods and intentions of more than one category as they have been described here; is not the purpose of this exhibition to separate still life from the rest of art and to assign it to categories. The division into symbolic, descriptive and interpretive forms has been used because it clarifies a study of modern concerns. These concerns, it can be seen, differ only slightly from those a half-century ago. Contemporary still life in this century is not very different from many forms of still life seen before; is, however, clearly American. The objects on tabletops are American televisions and telephones, American newspapers and cigarette packages, American cosmetics—somehow we even know it is American fruit, vegetables and flowers. American concern for objects has always been thought to be both a specific and somewhat naive one. There is a love of the way things in this country look and yet at the same time a resentment that these objects fill and obliterate the landscape. It is this obsession with objects which makes still life a natural, compelling subject for many American artists.

A shared characteristic among the three groups is the observation of forms found naturally. Objects often have natural relationships

26. Ross Field and Henry T. Hopkins, *Philip Guston* (New York: George Braziller, Inc., in association with the San Francisco Museum of Modern Art, California, 1981), p. 46.

each other and the description of those relationships provides a formal and intellectual challenge. Fairfield Porter said:

> . . . the dishes are in a certain arrangement at the end of a meal because people without thinking have moved things and then have gone away. And I think it's impossible not to get some sort of form if you don't think about it. If you do think about it you can get chaos. But if you don't think about it you get form.[27]

His remark identifies the American artist's interest in objects as well as the spaces between them. It is apparent that there is equal and parallel interest in the problems for painting present in both abstraction and realism.

It is possible to claim that the still life— a recognizable subject born of the realist traditions both old and current—has come back in as many forms as there are painters and sculptors. Artists are now not feeling so trapped by ideology that their individuality must suffer because of style and, further, that their choices of subject matter must be concerned with notions of major and minor themes.

American still life has been completely open to influences and interpretations and includes a balance of ideas. Still life has not dominated contemporary American art, but this exhibition reveals a continuing interest with new results. Many of the stylistic and technical achievements of the recognized major movements have been incorporated to distinctive ends and, thus, the European history of the genre has been continued and has been augmented and distinguished by uniquely American contributions.

Linda L. Cathcart

27. Ashbery and Moffett, *Fairfield Porter (1907–1975): Realist Painter in an Age of Abstraction*, p. 57.

CATALOGUE OF THE EXHIBITION

All dimensions are given in inches,
height preceding width, preceding depth.

MILTON AVERY

Watkins 9-2236 1945
Oil on canvas
22 x 28"
Collection Neuberger Museum,
State University of New York
at Purchase;
gift of Roy R. Neuberger

WILLIAM BAILEY

Still Life with Blue Stripes 1979
Oil on canvas
30 x 36"
Collection Shelly and Norman Dinhofer,
Brooklyn, New York

DAVID BATES

Sheep Heads and Shrimp 1983
Oil on canvas
36 x 48"
Courtesy the artist and
Charles Cowles Gallery,
New York City

Still Life with Fish Decoy 1983
Oil on canvas
32 x 24"
Courtesy the artist and
Charles Cowles Gallery,
New York City

ED BAYNARD

Mechanic Street #8 1976
Acrylic and stain on canvas
48 x 82½"
Collection Edward R. Downe, Jr.

Miranda 1983
Alkyd on canvas
82 x 75"
Courtesy Secor Investments, Inc./
Alexander F. Milliken Inc.,
New York City

JACK BEAL

Still Life Painter 1978–79
Oil on canvas
49¾ x 60"
Collection The Toledo Museum
of Art; Gift of Edward Drummond Libbey

THOMAS HART BENTON

Still Life with Silver Vase 1962
Oil on canvas board
23⅞ x 16"
Courtesy Lyman Field and United Missouri
Bank of Kansas City, N.A.,
Co-Trustees of the
Thomas Hart and Rita P. Benton Trusts

ED BLACKBURN

Black and White Still Life 1980
Acrylic on canvas and
mixed media sculpture
71 x 51¾ x 16"
Courtesy Moody Gallery,
Houston, Texas

NELL BLAINE

**Bouquet with Dark Cloth
and Marguerites** 1982
Oil on canvas
24 x 18"
Courtesy Fischbach Gallery,
New York City

TROY BRAUNTUCH

Untitled 1983
Pencil on cotton
98 x 111"
Collection Robert and Doris Hillman
Courtesy Mary Boone Gallery, New York City

VIJA CELMINS

Lamp #1 1964
Oil on canvas
24½ x 35"
Private Collection

Soup 1964
Oil on canvas
18¼ x 16⅛"
Private Collection

Robert Colescott

Happy Birthday (Artistry and Reality) 1980
Acrylic on canvas
16 x 18"
Courtesy Semaphore Gallery,
New York City

A Piece of Cake (Artistry and Reality) 1982
Acrylic on canvas
16 x 18"
Courtesy Semaphore Gallery,
New York City

Mary Ann Currier

Onions and Knife 1980
Oil pastel on paper
39¼ x 63"
Courtesy Alexander F. Milliken Inc.,
New York City

East Palatka Onions 1983
Oil pastel on paper
35½ x 59½"
Courtesy Alexander F. Milliken Inc.,
New York City

Richard Diebenkorn

Flower and Glass Stopper 1957
Oil on canvas
8¾ x 8¾"
Collection Mr. and Mrs. Richard Diebenkorn

Still Life with Letter 1961
Oil on canvas
20⅝ x 25⅝"
Collection Arts Commission
of San Francisco, San Francisco, California

Linda Etcoff

**Still Life with
Five of Hearts** 1983
Oil on canvas
48 x 66"
Courtesy The Harcus Gallery,
Boston, Massachusetts

Manny Farber

Rohmer's Knee 1982
Oil on board
72" diameter
Courtesy Oil and Steel Gallery,
New York City

Eric Fischl

Still Lives #1 1980
Oil on canvas
24 x 36"
Courtesy Mary Boone Gallery,
New York City

Janet Fish

Raspberries and Goldfish 1981
Oil on canvas
72 x 64"
Collection The Metropolitan
Museum of Art, New York
Purchase The Cape Branch Foundation
and Lila Acheson Wallace Gift, 1983

Seafood 1983
Oil on canvas
42 x 94"
Courtesy Robert Miller Gallery,
New York City

Audrey Flack

Chanel 1974
Acrylic on canvas
56 x 82"
Collection Mr. and Mrs. Morton G. Neumann
(Exhibited in Columbus, Purchase and Portland only)

Gambler's Cabinet 1976
Oil over acrylic on canvas
78 x 78"
Collection Susan Pear and Louis K. Meisel
(Exhibited in Houston and Buffalo only)

Alice Forman

Lavinio Pitcher II 1983
Oil on canvas
56 x 48"
Courtesy Kornblee Gallery,
New York City

JANE FREILICHER

Fish, Onions, Flowers and Photo 1981
Oil on canvas
40 x 40"
Courtesy Fischbach Gallery,
New York City

Light from Above 1982
Oil on canvas
76 x 76"
Courtesy Fischbach Gallery,
New York City

ALBERT EUGENE GALLATIN

Untitled #54 1945
Oil on canvas
24 x 20"
Courtesy Meredith Long & Co.,
Houston, Texas

JEDD GARET

Spiral Vase 1979
Acrylic on masonite
28½ x 22¾ x 3"
Collection Ian Glennie,
Houston, Texas

Behind Your Back 1982
Acrylic on canvas
73 x 57 x 3½"
Courtesy Robert Miller Gallery,
New York City

GREGORY GILLESPIE

Forty-Fifth Birthday 1980–81
Mixed media on board
60 x 60"
Courtesy Forum Gallery,
New York City

RALPH GOINGS

Still Life with Creamer 1982
Oil on canvas
38 x 52"
Collection Ivan and Marilynn Karp

MORRIS GRAVES

Spring Bouquet 1975
Tempera on paper
23¼ x 35"
Private Collection, Extended Loan
to the Des Moines Art Center
(Exhibited in Houston, Buffalo,
Columbus and Purchase only)

Winter Still Life 1975
Tempera on paper
18 x 22¼"
Private Collection

PHILIP GUSTON

Anxiety 1975
Oil on canvas
57½ x 80¼"
Courtesy David McKee Gallery,
New York City

Pink Summer 1975
Oil on canvas
69 x 78½"
Courtesy David McKee Gallery,
New York City

HANS HOFMANN

Fruit Bowl 1950
Oil on canvas
29⅞ x 38"
Collection Nebraska Art
Association, courtesy
Sheldon Memorial Art Gallery,
University of Nebraska-Lincoln

Magenta and Blue 1950
Oil on canvas
48 x 58"
Collection Whitney Museum
of American Art, New York;
purchase, 1950

Neil Jenney

Paint and Painted 1970
Acrylic and graphite on canvas
43¾ x 43¾"
Collection Edward R. Downe, Jr.

Jasper Johns

Bronze 1960–61
Bronze
3½ x 11 x 6¼"
Collection the artist

Alex Katz

Flowers on White Chair 1955
Oil on masonite
42 x 20"
Courtesy Robert Miller Gallery,
New York City

Flowers 1965
Oil on masonite
23¾ x 23¾"
Courtesy Robert Miller Gallery,
New York City

Yasuo Kuniyoshi

Fish Head 1952
Pen, ink and wash on paper
22 x 28"
Collection The Metropolitan
Museum of Art, New York
Rogers Fund, 1953
(Exhibited in Houston, Buffalo and Columbus only)

Gabriel Laderman

Still Life #5 1970
Oil on canvas
40 x 50"
Courtesy Robert Schoelkopf Gallery,
New York City

John Lees

Painting Table II 1976
Oil on canvas
40 x 32"
Collection James F. Duffy, Jr.,
Detroit, Michigan

Vase 1980–82
Oil on canvas
22½ x 15½"
Collection Mr. Nicholas Wilder,
New York City
Courtesy Edward Thorp Gallery,
New York City

Alfred Leslie

Television Moon 1978–79
Oil on canvas
72 x 84"
Collection Wichita Art Museum,
Wichita, Kansas

Roy Lichtenstein

Still Life with Crystal Bowl 1973
Oil and magna on canvas
52 x 42"
Collection Whitney Museum
of American Art, New York;
Gift of Frances and Sidney
Lewis, 1977

Picture and Pitcher 1977
Painted fabricated aluminum
95 x 40 x 24½"
Collection Albright-Knox
Art Gallery, Buffalo, New York,
Edmund Hayes and Charles Clifton Funds, 1978

Louisa Matthiasdottir

Still Life with Pumpkin 1975
Oil on canvas
28 x 36"
Courtesy Robert Schoelkopf Gallery,
New York City

**Still Life with
Chinese Eggplants, Green Plate
and Mirror** 1981
Oil on canvas
37 x 52³⁄₁₆"
Collection The Continental Corporation,
New York City

NANCY MITCHNICK

Emily 1976–81
Oil on canvas
74 x 72"
Courtesy Hirschl & Adler Modern,
New York City

Podium 1981
Oil on canvas
84 x 42"
Courtesy Hirschl & Adler Modern,
New York City

MALCOLM MORLEY

Fish Soup 1976
Watercolor on paper
30 x 22¼"
Courtesy Xavier Fourcade, Inc.,
New York City

WALTER MURCH

Still Life with Red Ribbon 1945
Oil on canvas
15⅛ x 19⅛"
Courtesy Sid Deutsch Gallery,
New York City
(Exhibited in Houston, Buffalo,
Columbus and Purchase only)

The Light 1959
Oil on canvas
15¾ x 20¾"
Collection Albright-Knox
Art Gallery, Buffalo, New York,
George Cary Fund, 1959

CATHERINE MURPHY

Still Life with Envelopes 1976
Oil on canvas
28 x 22"
The Phillips Collection,
Washington, D.C.

Bedside Still Life 1982
Oil on canvas
27 x 19"
Courtesy Xavier Fourcade, Inc.,
New York City

ALICE NEEL

Fish Still Life 1945
Oil on canvas
18 x 22"
Courtesy Robert Miller Gallery,
New York City

Cut Glass with Fruit 1952
Oil on canvas
21 x 31"
Courtesy Robert Miller Gallery,
New York City

Natura Morta 1964–65
Oil on canvas
31 x 45"
Courtesy Robert Miller Gallery,
New York City

JUD NELSON

Toilet Paper #VI 1982
Carrara marble
9 x 8 x 8"
Courtesy Louis K. Meisel Gallery,
New York City

Toilet Paper #IX 1982
Carrara marble
9 x 8 x 8"
Courtesy Louis K. Meisel Gallery,
New York City

CLAES OLDENBURG

Soft Baked Potato 1970
Canvas and wood
10 x 16 x 18"
Courtesy Janie C. Lee Gallery, Houston, Texas
(Exhibited in Houston only)

RICHARD PICCOLO

Still Life in Landscape 1975
Oil on canvas
37 x 61⅝"
Courtesy Robert Schoelkopf
Gallery, New York City

**Still Life with Mt. Acuto
in Background** 1975
Oil on canvas
27½ x 31⅜"
Courtesy Robert Schoelkopf Gallery,
New York City

Fairfield Porter

Still Life 1959
Oil on canvas
32 x 22″
Courtesy Hirschl & Adler Modern,
New York City

White Lilacs 1964
Oil on canvas
15½ x 14½″
Courtesy Gross McCleaf Gallery,
Philadelphia, Pennsylvania

Larry Rivers

Webster and His Cigars 1964–66
Mixed media collage
on wood construction
16 x 13¼ x 13¼″
Collection Mrs. Pollard Marsters,
Houston, Texas

Harry Roseman

T.V. Still Life 1970
Bronze
Ed. ⅛
10¾ x 10¾ x 1½″
Collection Mr. and Mrs. Sidney Roseman
Courtesy Daniel Weinberg Gallery,
Los Angeles/San Francisco, California

Studio Still Life 1972–73
Bronze
Ed. ⅙
12¾ x 16½ x ½″
Courtesy Daniel Weinberg Gallery,
Los Angeles/San Francisco, California

Lucas Samaras

Dinner #2 1962
Mixed media
7½ x 13¾ x 9¾″
Collection The Minneapolis
Institute of Arts, Gift of
Gordon Locksley and George Shea

George Segal

Cézanne Still Life #3 1981
Painted plaster, wood and metal
24 x 40 x 27½″
Courtesy Sidney Janis Gallery,
New York City

Still Life with Red Ball 1982
Painted plaster and wood
36½ x 17 x 9½″
Courtesy Sidney Janis Gallery,
New York City

Richard Shaw

Book Jar with Cigarettes 1982
Porcelain
5 x 9¼ x 7″
Courtesy Allan Frumkin Gallery,
New York City

**Book Jar with Ink Bottle
and Money** 1982
Porcelain
8 x 7 x 10″
Courtesy Allan Frumkin Gallery,
New York City

Charles Sheeler

Classic Still Life 1947
Tempera on paper
15⅝ x 13½″
Collection Neuberger Museum,
State University of New York
at Purchase; gift of Roy R. Neuberger

David Smith

Voltri XVI 1962
Steel
44 x 40 x 38″
Collection Candida and Rebecca Smith
Courtesy M. Knoedler & Co., Inc.,
New York City

Niles Spencer

The Desk 1948
Oil on canvas
24½ x 32⅜″
Collection San Francisco Museum
of Modern Art; Gift of
the Women's Board
(Exhibited in Houston, Buffalo,
Columbus and Purchase only)

SAUL STEINBERG

Medaglio D'Oro Still Life 1952
Ink on paper
14½ x 23″
Courtesy The Pace Gallery,
New York City

Drawing Table with Stand 1974
Collage on wood
34 x 23 x 31″
Collection Martin Z. Margulies,
Miami, Florida
(Exhibited in Houston only)

Still Life with Watercolor Set 1974
Watercolor and graphite on paper
17 x 21¾″
Courtesy The Pace Gallery,
New York City

BILLY SULLIVAN

Summer Breakfast 1979
Pastel on paper
41¼ x 34½″
Courtesy Kornblee Gallery,
New York City

Summer Lunch with Vase 1979
Pastel on paper
43 x 30½″
Courtesy Kornblee Gallery,
New York City

JIM SULLIVAN

Harvest 1982
Oil over acrylic molding paste
and wood on canvas
60 x 80″
Courtesy Nancy Hoffman Gallery,
New York City

WAYNE THIEBAUD

Around the Cake 1962
Oil on canvas
22 x 28″
Collection Spencer Museum of Art,
The University of Kansas;
Gift of Ralph T. Coe
in memory of Helen F. Spencer

Boston Cremes 1962
Oil on canvas
14 x 18″
Collection Crocker Art Museum;
Gift of the Crocker Art
Gallery Association

SIDNEY TILLIM

Penholder Still Life 1966
Oil on canvas
19 x 24″
Collection Mrs. Muriel Tillim

Radio and Sofa 1967
Oil on canvas
30 x 36″
Wellington Management Company/
Thorndike, Doran, Paine &
Lewis Collection

JAMES VALERIO

Still Life #2 1978
Oil on canvas
93½ x 116″
Collection of Graham Gund

ANDY WARHOL

Skull 1975
Acrylic and silkscreen on canvas
15 x 19″
Collection Mr. and Mrs.
Edward R. Hudson, Jr.

Hammer and Sickle 1976
Acrylic and silkscreen on canvas
18⅞ x 15″
Courtesy Texas Gallery, Houston, Texas

TOM WESSELMANN

Drawing 1964 for Still Life No. 42 1964
Construction
48⅛ x 60 x 10"
The James and Mari Michener Collection,
The Archer M. Huntington Art Gallery,
The University of Texas at Austin
(Exhibited in Houston, Buffalo,
and Columbus only)

**Tulip and Smoking
Cigarette** 1983
Painted metal
82 x 121 x 74"
Courtesy Sidney Janis Gallery,
New York City and
Delahunty Gallery, Dallas, Texas

PAUL WIESENFELD

Coffee Service 1981
Oil on canvas
32 x 51"
Courtesy Robert Schoelkopf Gallery,
New York City

DONALD ROLLER WILSON

**A Pink Chair with a
Black Mans Belt** 1982
Oil on canvas
25 x 22"
Collection Charles E. Pattin,
Houston, Texas

JANE WILSON

Blue Carafe 1979–81
Oil on canvas
30 x 30"
Courtesy Fischbach Gallery,
New York City

PAUL WONNER

**Glass, Lemon, Dish,
Postcard (Vermeer)** 1968
Oil on canvas
48 x 48"
Collection Dr. and Mrs.
Lawrence Rappaport,
Davis, California

**Dutch Still Life with
Piece of Pie and Piece
of Cheese** 1977–81
Acrylic on canvas
70 x 48"
Collection John Berggruen,
San Francisco, California

ALBERT YORK

Posies in a Tin c. 1966
Oil on wood
11 x 11¾"
Courtesy Davis & Langdale
Company, Inc., New York City

**Two Pink Anemones in a
Glass Vase in a Landscape** 1982
Oil on masonite
14 x 12½"
Collection Clifford Ross

JOE ZUCKER

Vases 1983
Acrylic, rhoplex and
cotton on burlap
Two panels of a five panel piece
82 x 60" each
Collection The Fort Worth
Art Museum
(Exhibited in Houston, Buffalo,
and Columbus only)

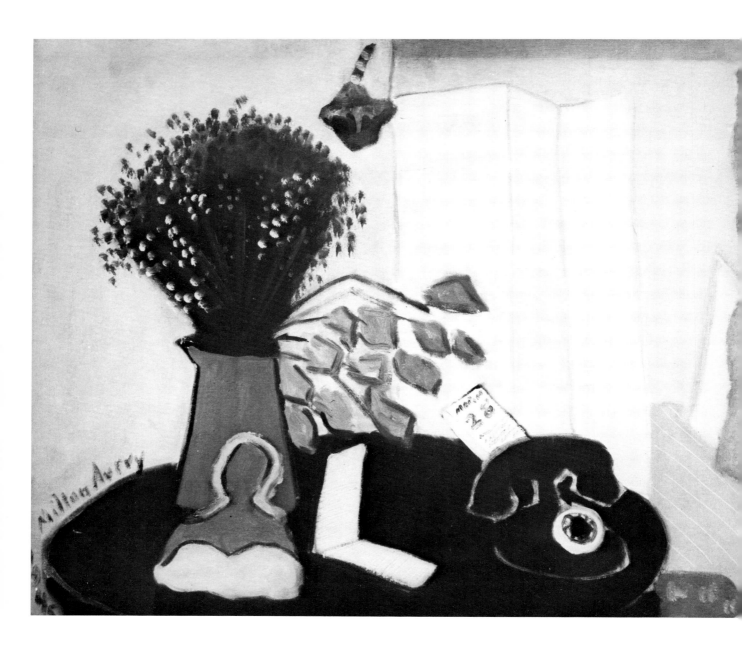

Watkins 9-2236 1945
Oil on canvas
22 x 28″
Collection Neuberger Museum,
State University of New York
at Purchase; gift of Roy R. Neuberger

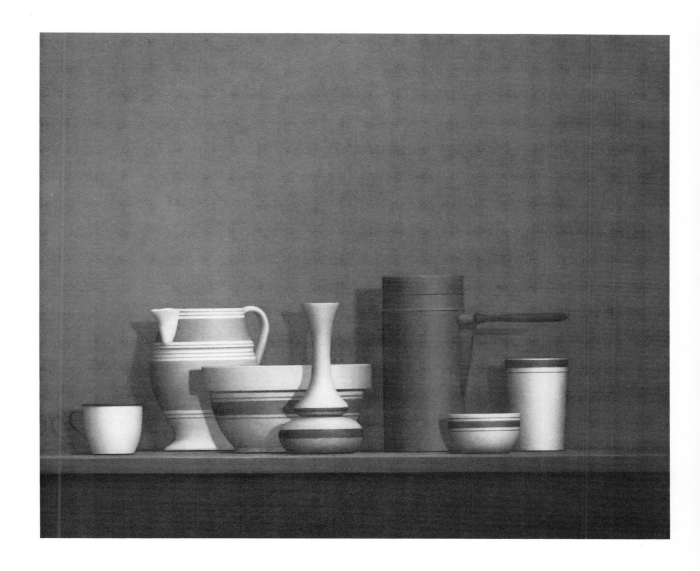

Still Life with Blue Stripes 1979
Oil on canvas
30 x 36″
Collection Shelly and Norman Dinhofer,
Brooklyn, New York

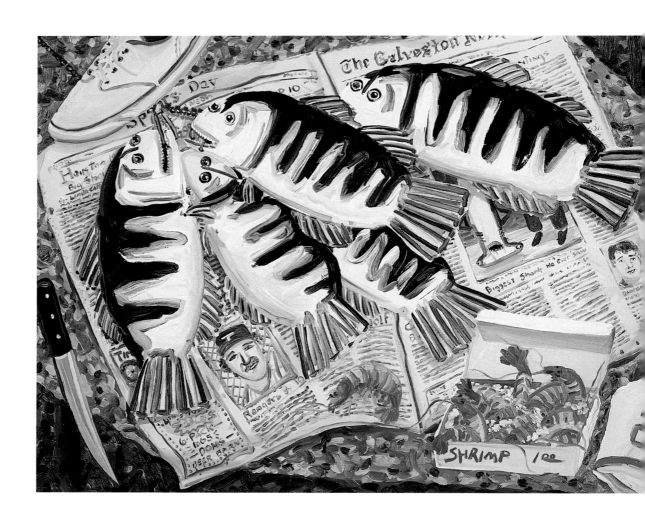

Sheep Heads and Shrimp 1983
Oil on canvas
36 x 48"
Courtesy the artist and
Charles Cowles Gallery,
New York City

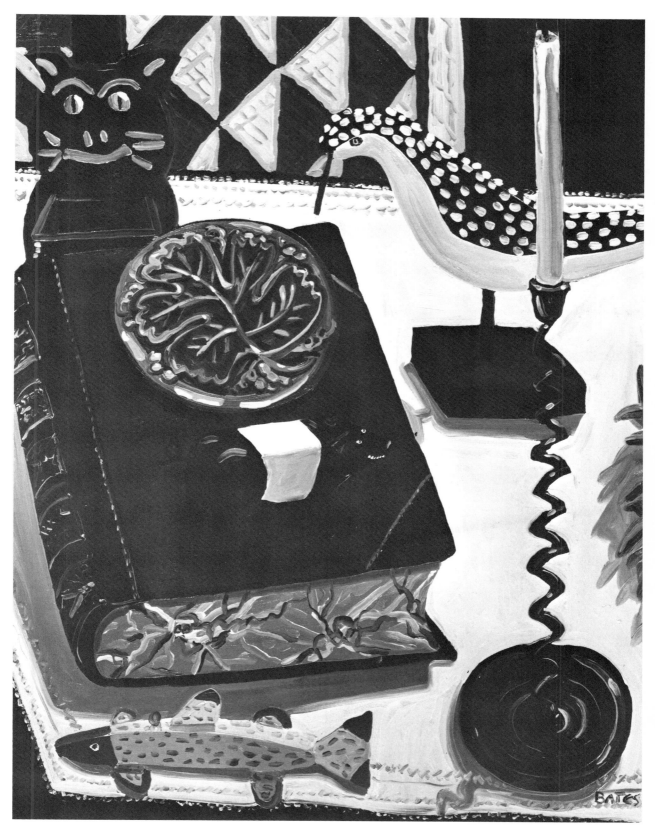

Still Life with Fish Decoy 1983
Oil on canvas
32 x 24″
Courtesy the artist and
Charles Cowles Gallery,
New York City

Mechanic Street #8 1976
Acrylic and stain on canvas
48 x 82½″
Collection Edward R. Downe, Jr.

Miranda 1983
Alkyd on canvas
82 x 75″
Courtesy Secor Investments, Inc./
Alexander F. Milliken Inc.,
New York City

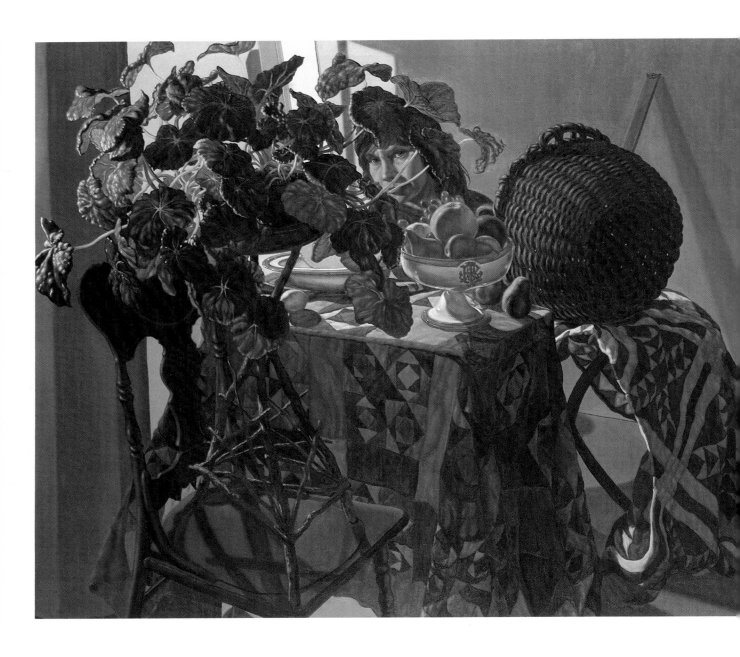

Still Life Painter 1978–79
Oil on canvas
49¾ x 60″
Collection The Toledo Museum of Art;
Gift of Edward Drummond Libbey

Life with Silver Vase 1962
canvas board
16″
esy Lyman Field and United Missouri
of Kansas City, N.A.,
ustees of the
as Hart and Rita P. Benton Trusts

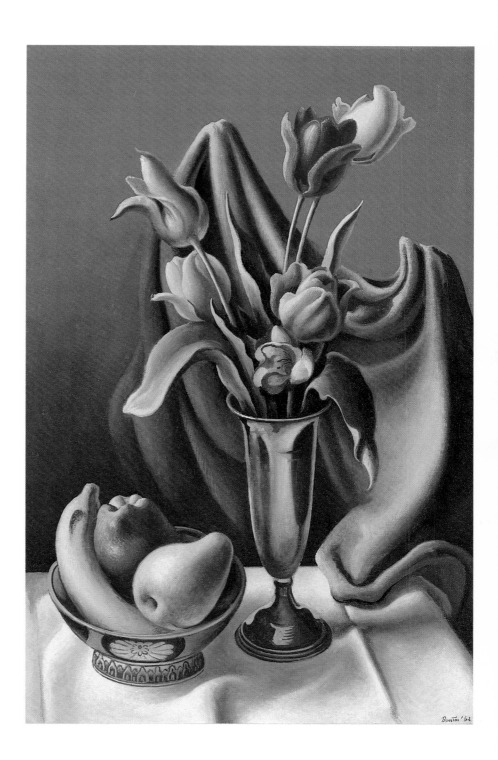

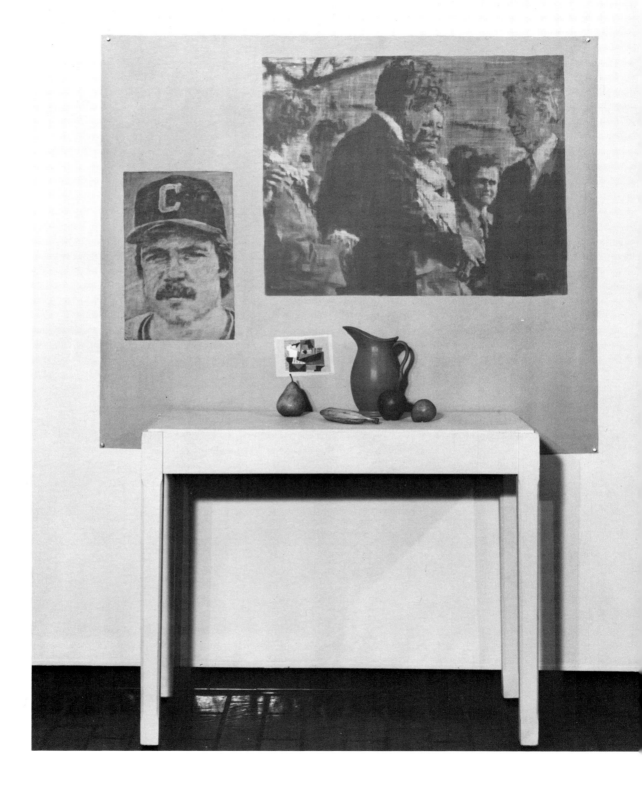

Black and White Still Life 1980
Acrylic on canvas
and mixed media sculpture
71 x 51¾ x 16″
Courtesy Moody Gallery,
Houston, Texas

**Bouquet with Dark Cloth
and Marguerites** 1982
Oil on canvas
24 x 18″
Courtesy Fischbach Gallery,
New York City

Untitled 1983
Pencil on cotton
98 x 111"
Collection Robert and Doris Hillman
Courtesy Mary Boone Gallery, New York City

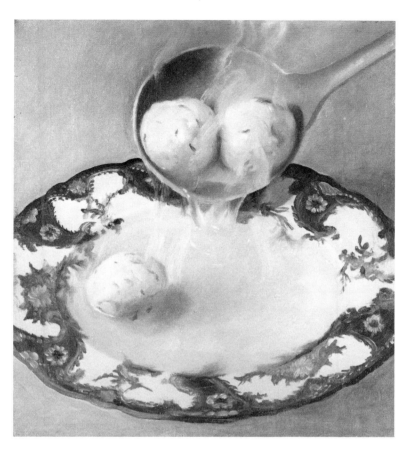

Soup 1964
Oil on canvas
18¼ x 16⅛"
Private Collection

Lamp #1 1964
Oil on canvas
24½ x 35"
Private Collection

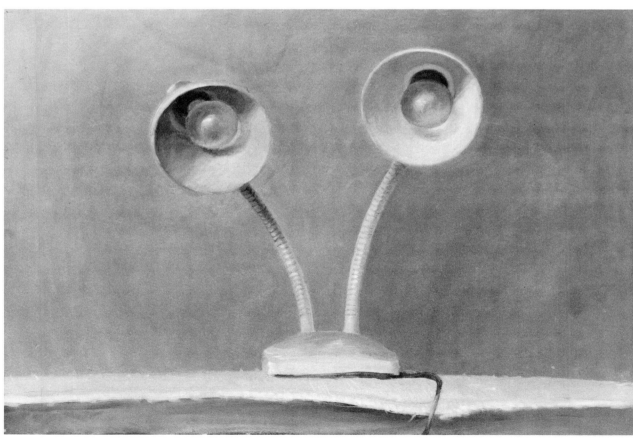

A Piece of Cake
(Artistry and Reality) 1982
Acrylic on canvas
16 x 18″
Courtesy Semaphore Gallery,
New York City

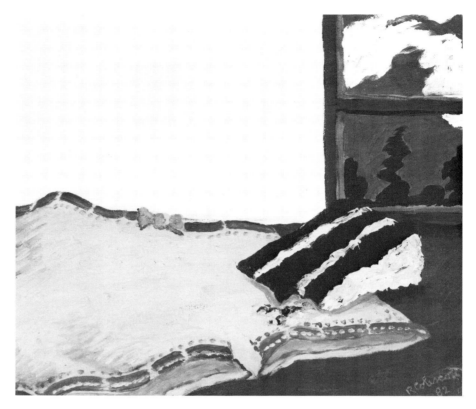

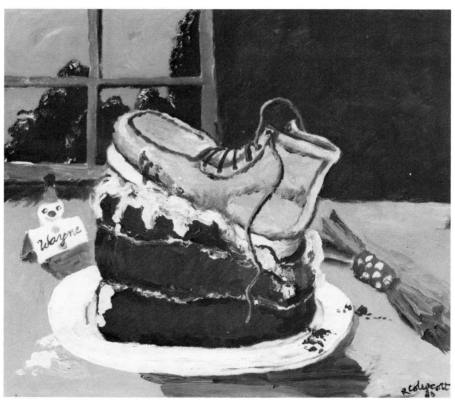

Happy Birthday
(Artistry and Reality) 1980
Acrylic on canvas
16 x 18″
Courtesy Semaphore Gallery,
New York City

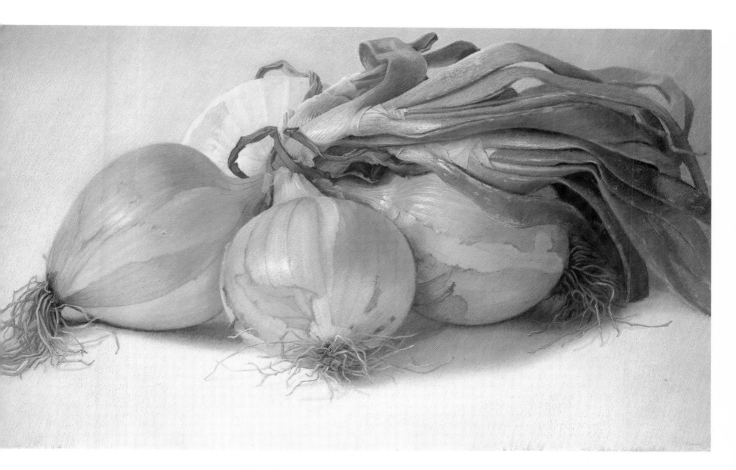

Palatka Onions 1983
astel on paper
x 59½"
:esy Alexander F. Milliken Inc.,
York City

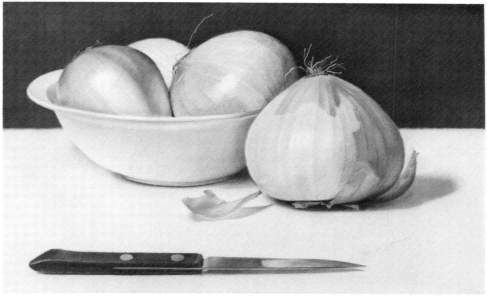

Onions and Knife 1980
Oil pastel on paper
39¼ x 63"
Courtesy Alexander F. Milliken Inc.,
New York City

Flower and Glass Stopper 1957
Oil on canvas
8¾ x 8¾"
Collection Mr. and Mrs. Richard Diebenkorn

Still Life with Letter 1961
Oil on canvas
20⅝ x 25⅝"
Collection Arts Commission
of San Francisco, San Francisco, California

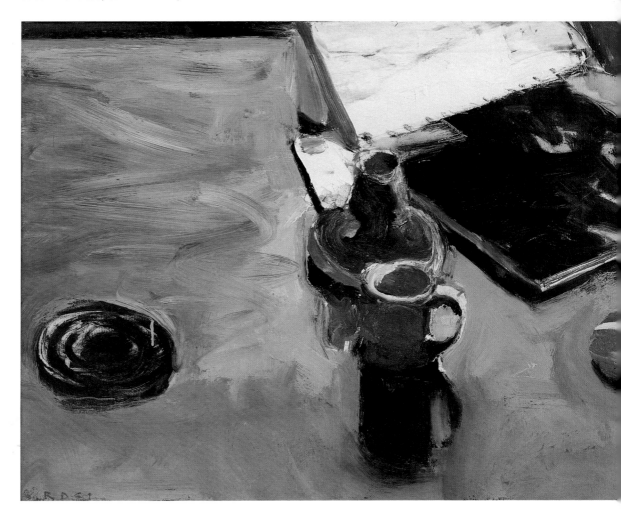

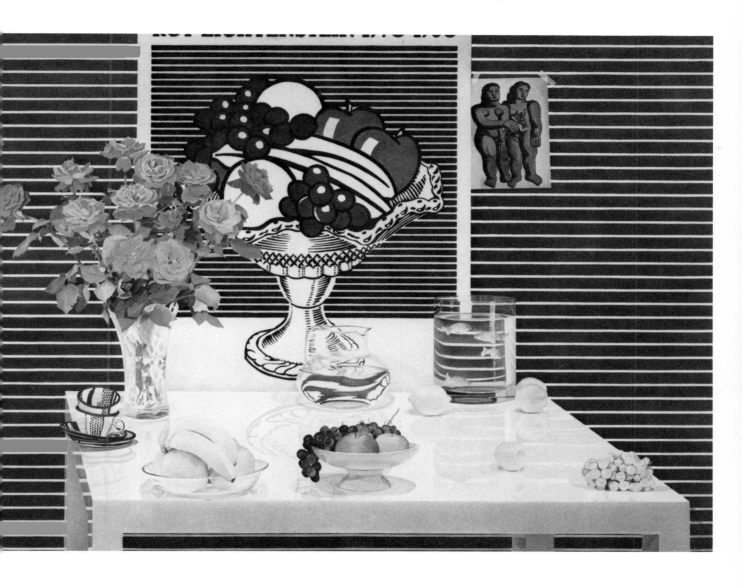

**Still Life with
Five of Hearts** 1983
Oil on canvas
48 x 66"
Courtesy The Harcus Gallery,
Boston, Massachusetts

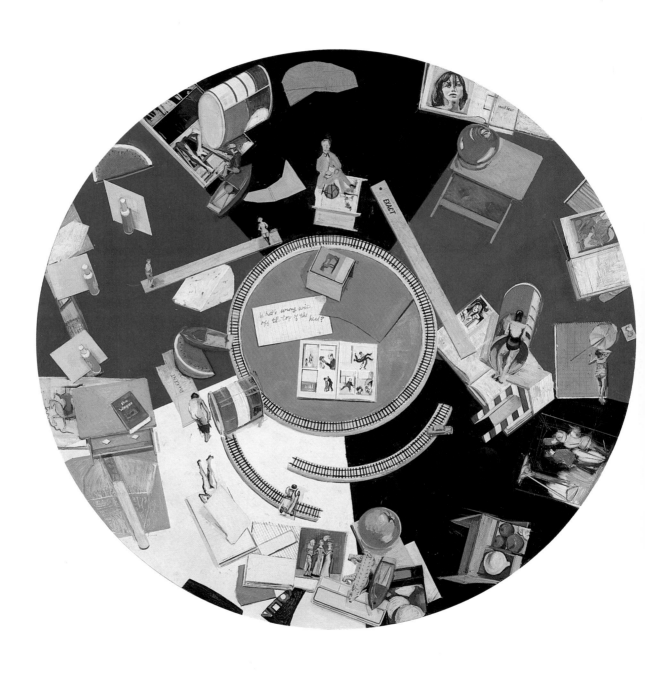

Rohmer's Knee 1982
Oil on board
72″ diameter
Courtesy Oil and Steel Gallery,
New York City

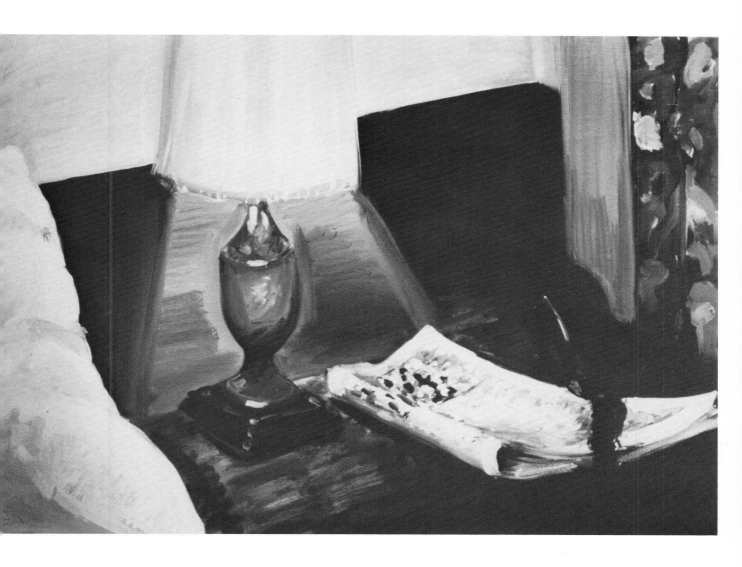

Still Lives #1 1980
Oil on canvas
24 x 36″
Courtesy Mary Boone Gallery,
New York City

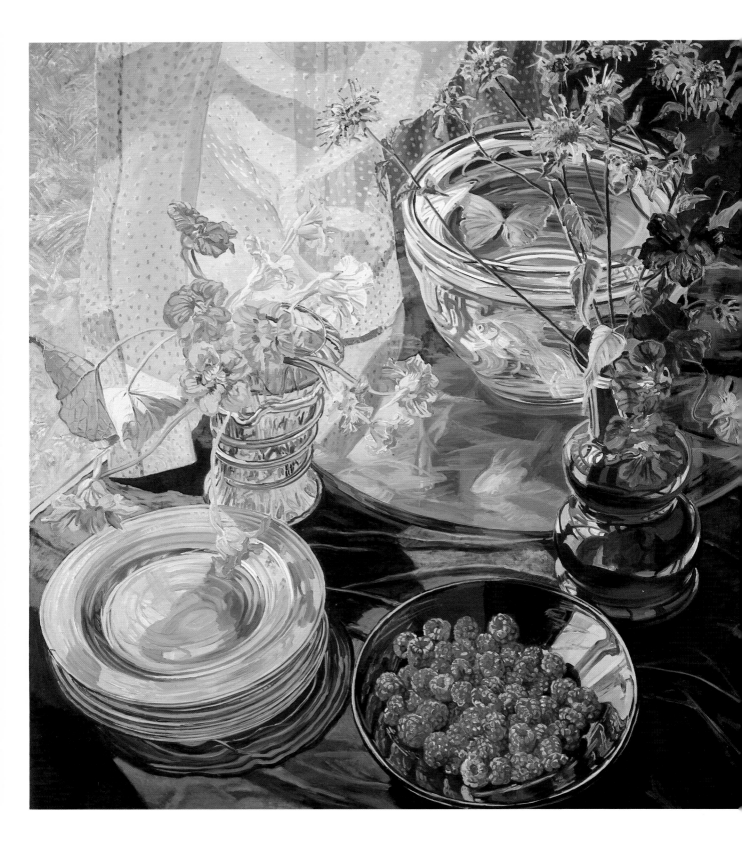

Raspberries and Goldfish 1981
Oil on canvas
72 x 64″
Collection The Metropolitan
Museum of Art, New York
Purchase The Cape Branch Foundation
and Lila Acheson Wallace Gift, 1983

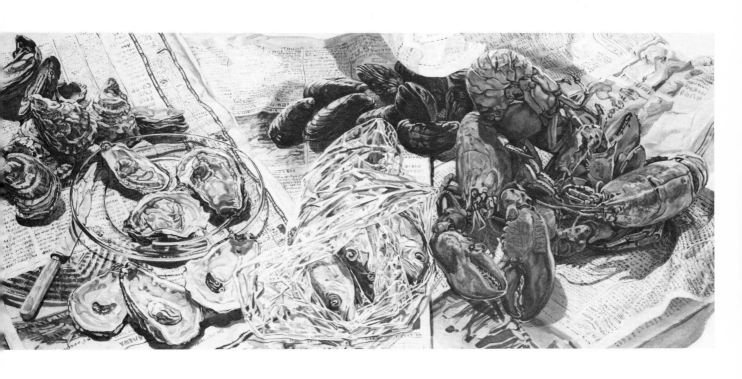

Seafood 1983
Oil on canvas
42 x 94″
Courtesy Robert Miller Gallery,
New York City

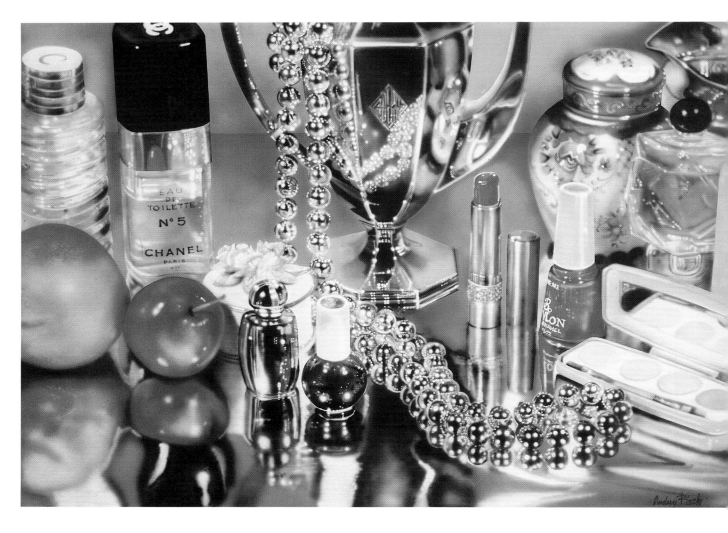

Chanel 1974
Acrylic on canvas
56 x 82"
Collection Mr. and Mrs. Morton G. Neumann

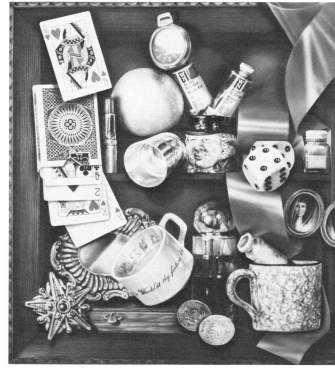

Gambler's Cabinet 1976
Oil over acrylic on canvas
78 x 78"
Collection Susan Pear and Louis K. Meisel

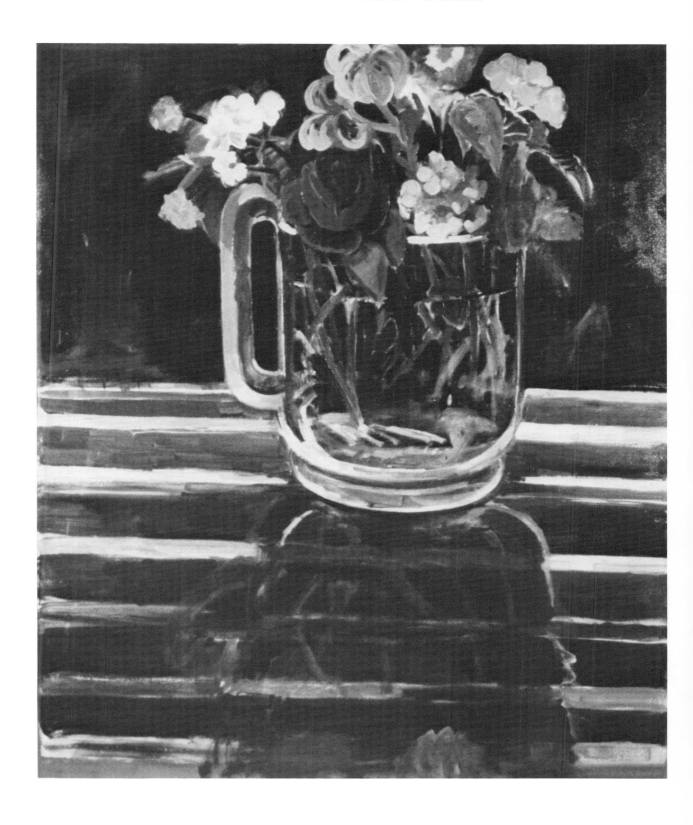

Lavinio Pitcher II 1983
Oil on canvas
56 x 48″
Courtesy Kornblee Gallery,
New York City

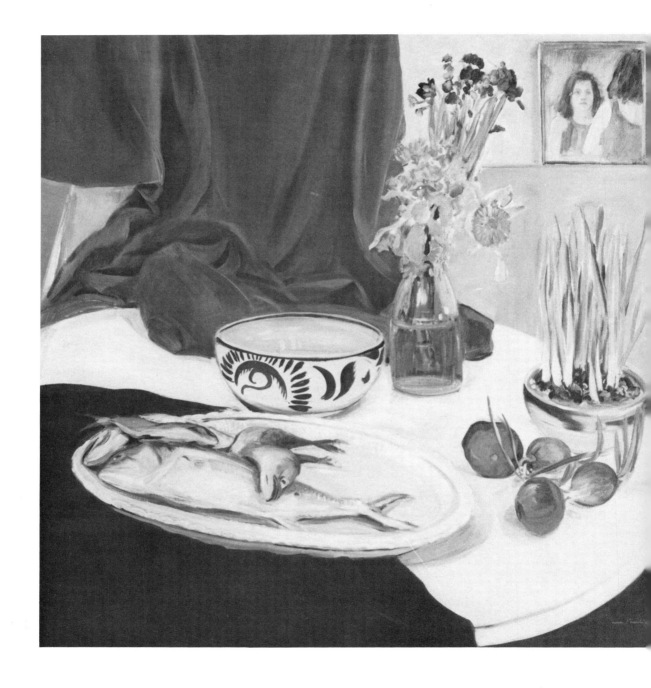

**Fish, Onions, Flowers
and Photo** 1981
Oil on canvas
40 x 40″
Courtesy Fischbach Gallery,
New York City

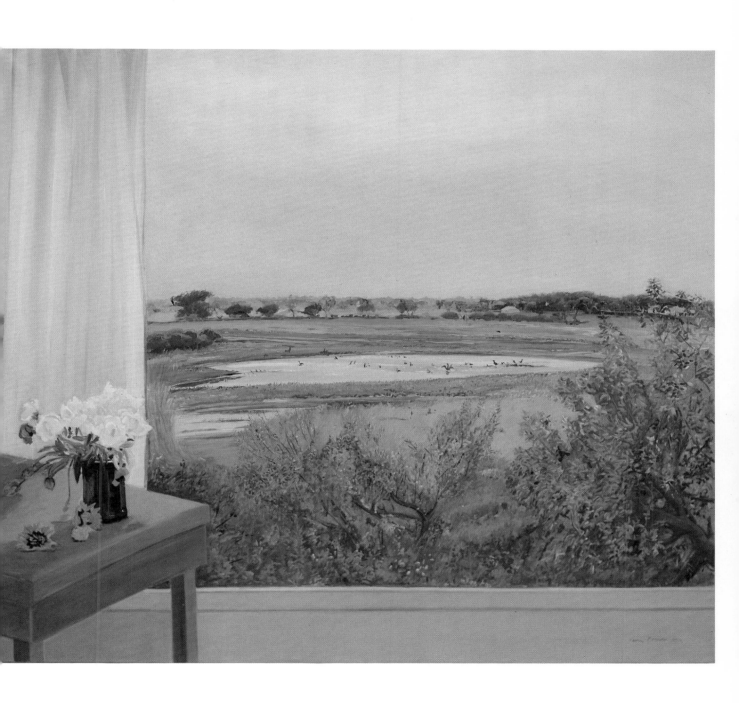

Light from Above 1982
Oil on canvas
76 x 76"
Courtesy Fischbach Gallery,
New York City

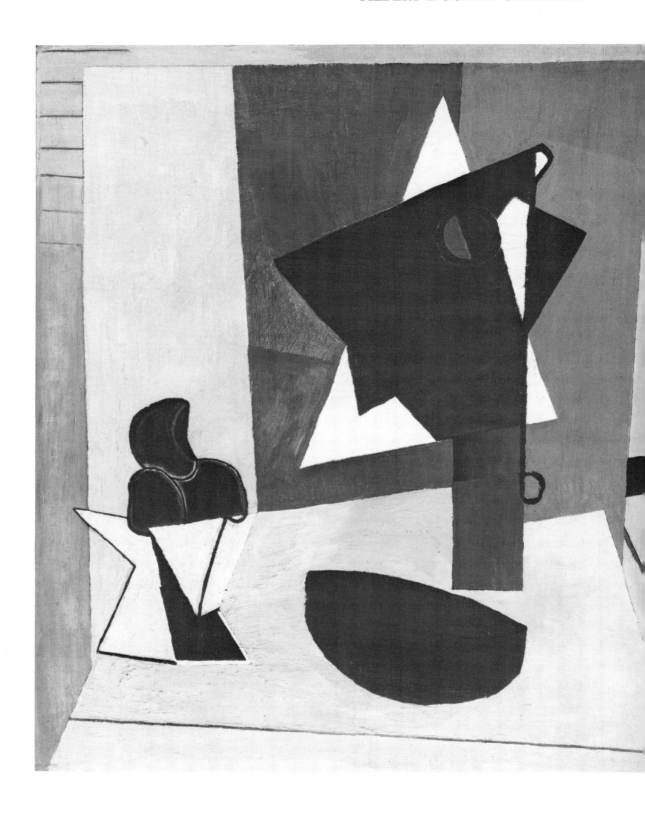

Untitled #54 1945
Oil on canvas
24 x 20″
Courtesy Meredith Long & Co.,
Houston, Texas

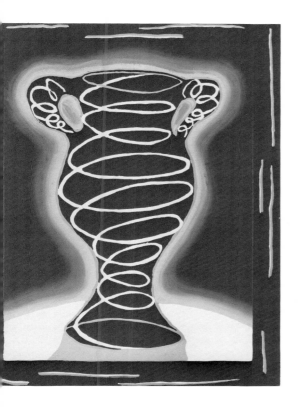

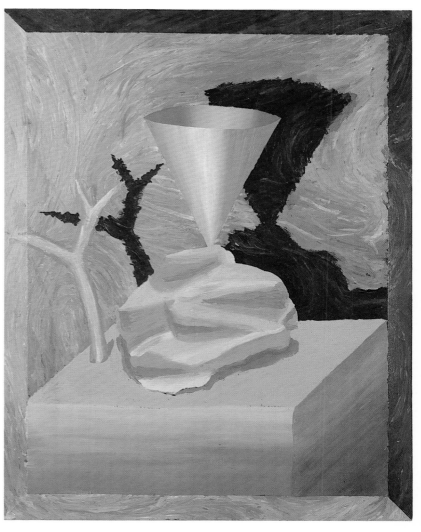

Spiral Vase 1979
Acrylic on masonite
28½ x 22¾ x 3″
Collection Ian Glennie,
Houston, Texas

Behind Your Back 1982
Acrylic on canvas
73 x 57 x 3½″
Courtesy Robert Miller Gallery,
New York City

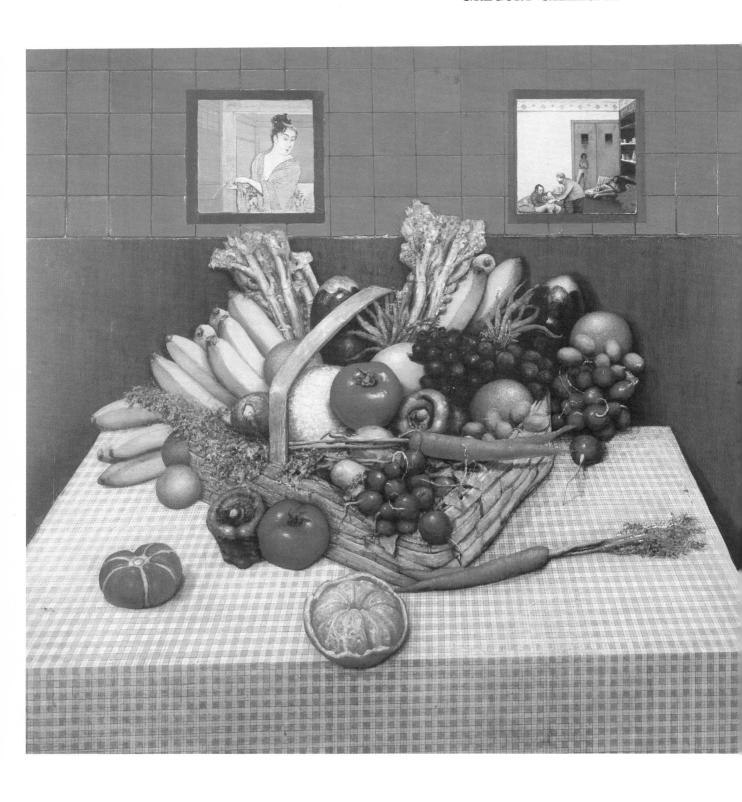

Forty-Fifth Birthday 1980–81
Mixed media on board
60 x 60″
Courtesy Forum Gallery,
New York City

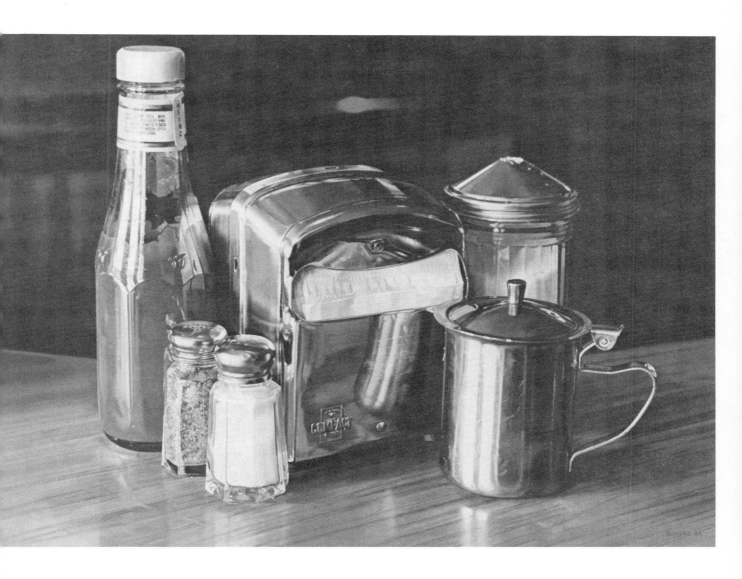

Still Life with Creamer 1982
Oil on canvas
38 x 52"
Collection Ivan and Marilynn Karp

Winter Still Life 1975
Tempera on paper
18 x 22¼"
Private Collection

Spring Bouquet 1975
Tempera on paper
23¼ x 35″
Private Collection,
Extended Loan to the
Des Moines Art Center

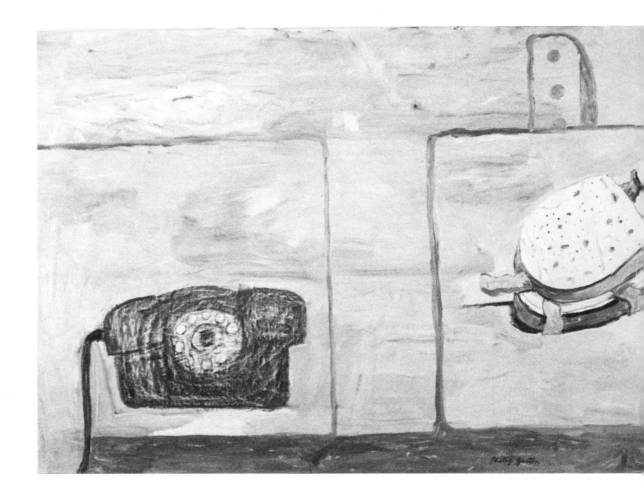

Anxiety 1975
Oil on canvas
57½ x 80¼"
Courtesy David McKee Gallery,
New York City

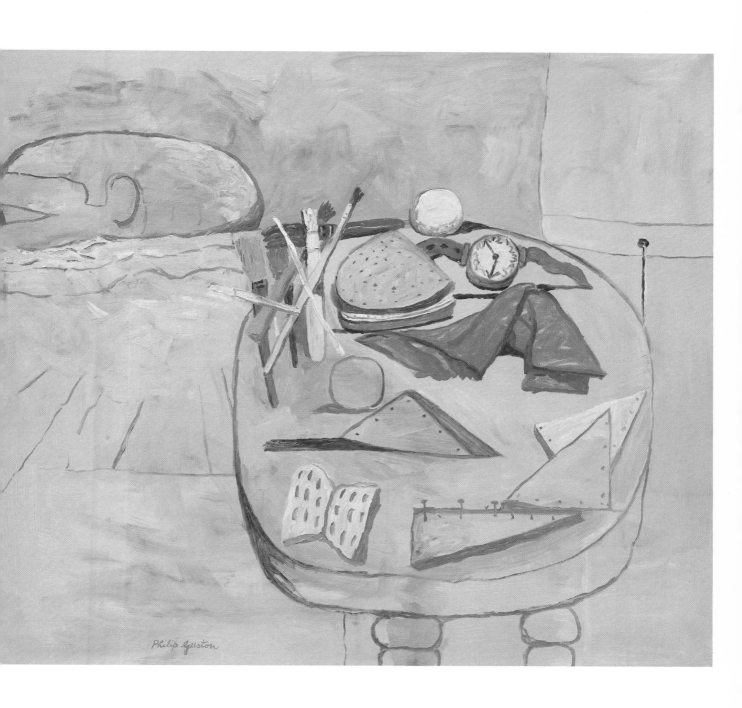

Pink Summer 1975
Oil on canvas
69 x 78½"
Courtesy David McKee Gallery,
New York City

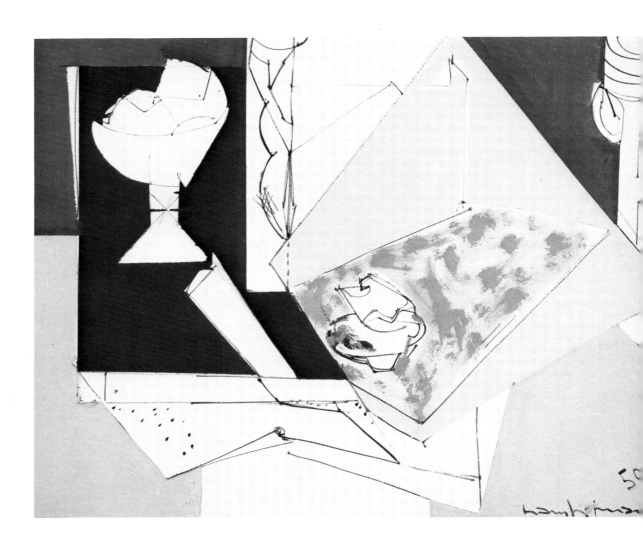

Fruit Bowl 1950
Oil on canvas
29⅞ x 38″
Collection Nebraska Art
Association, courtesy
Sheldon Memorial Art Gallery,
University of Nebraska-Lincoln

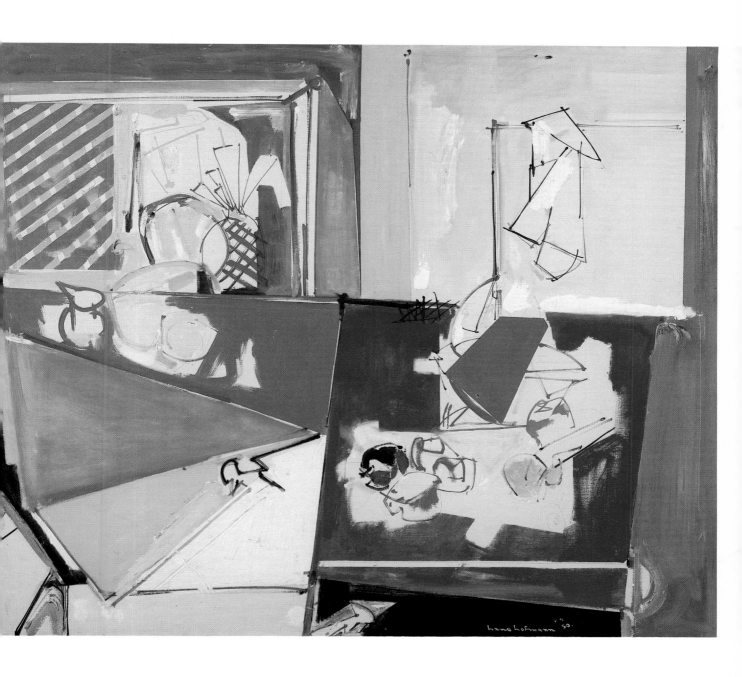

Magenta and Blue 1950
Oil on canvas
48 x 58″
Collection Whitney Museum
of American Art, New York; purchase, 1950

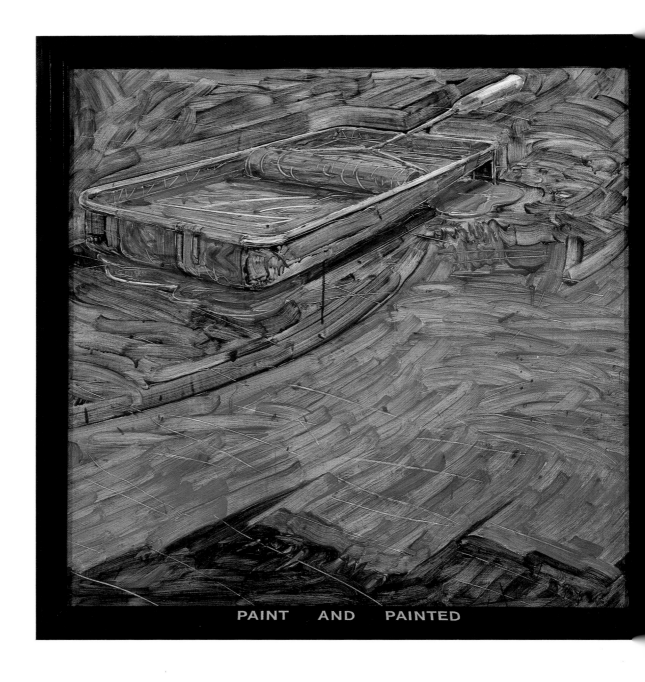

PAINT AND PAINTED

Paint and Painted 1970
Acrylic and graphite on canvas
43¾ x 43¾″
Collection Edward R. Downe, Jr.

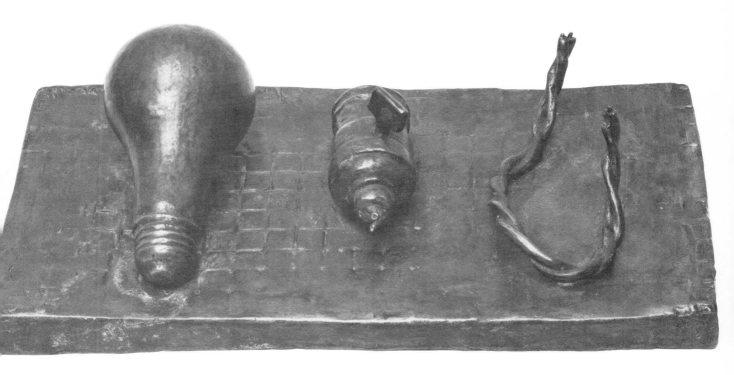

Bronze 1960–61
Bronze
3½ x 11½ x 6¼"
Collection the artist

Flowers on White Chair 1955
Oil on masonite
42 x 20″
Courtesy Robert Miller Gallery,
New York City

Flowers 1965
Oil on masonite
23¾ x 23¾"
Courtesy Robert Miller Gallery,
New York City

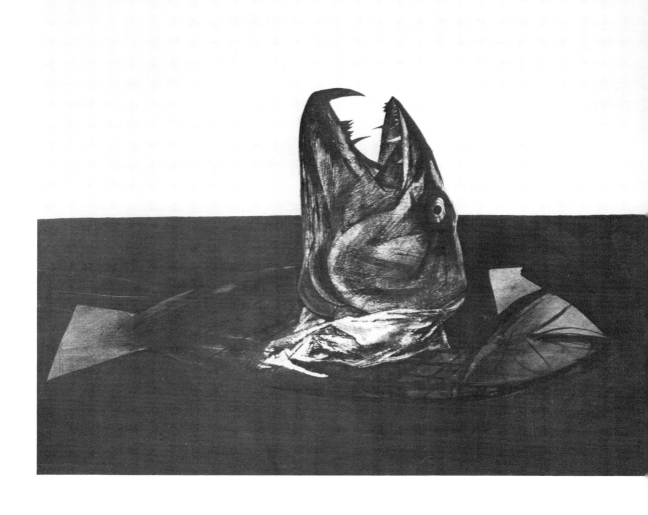

Fish Head 1952
Pen, ink and wash on paper
22 x 28"
Collection The Metropolitan Museum of Art, New York
Rogers Fund, 1953

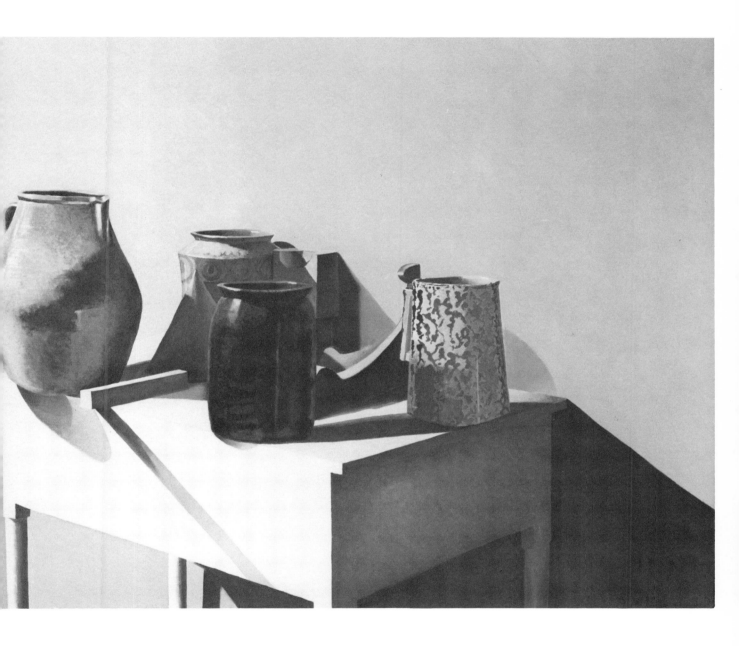

Still Life #5 1970
Oil on canvas
40 x 50″
Courtesy Robert Schoelkopf Gallery,
New York City

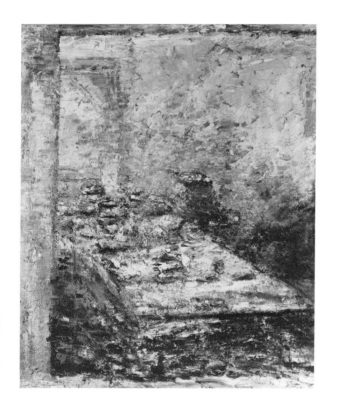

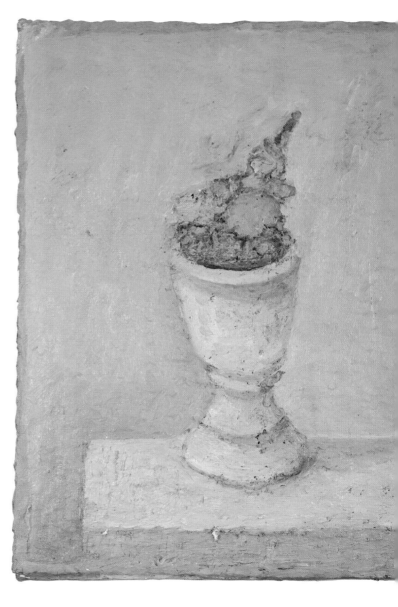

Painting Table II 1976
Oil on canvas
40 x 32″
Collection James F. Duffy, Jr.,
Detroit, Michigan

Vase 1980–82
Oil on canvas
22½ x 15½″
Collection Mr. Nicholas Wilder,
New York City
Courtesy Edward Thorp Gallery,
New York City

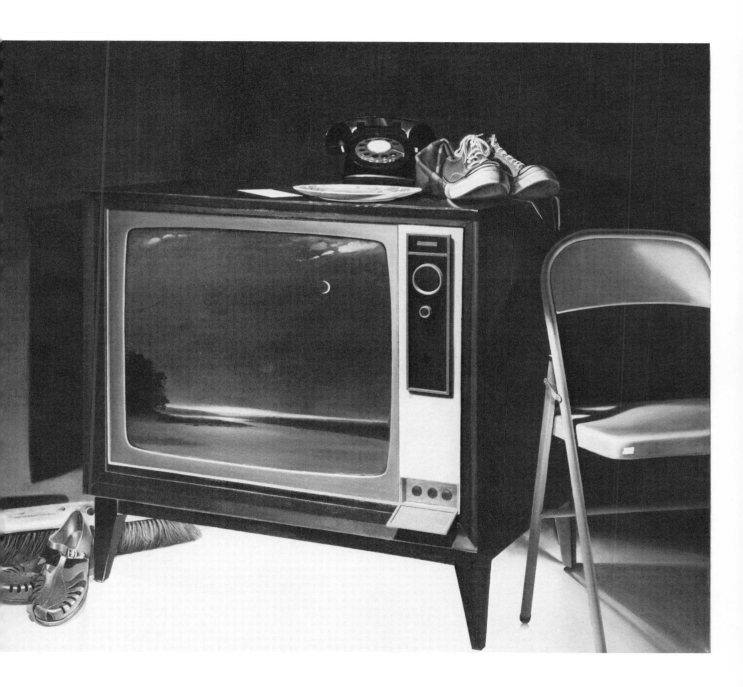

Television Moon 1978–79
Oil on canvas
72 x 84"
Collection Wichita Art Museum,
Wichita, Kansas

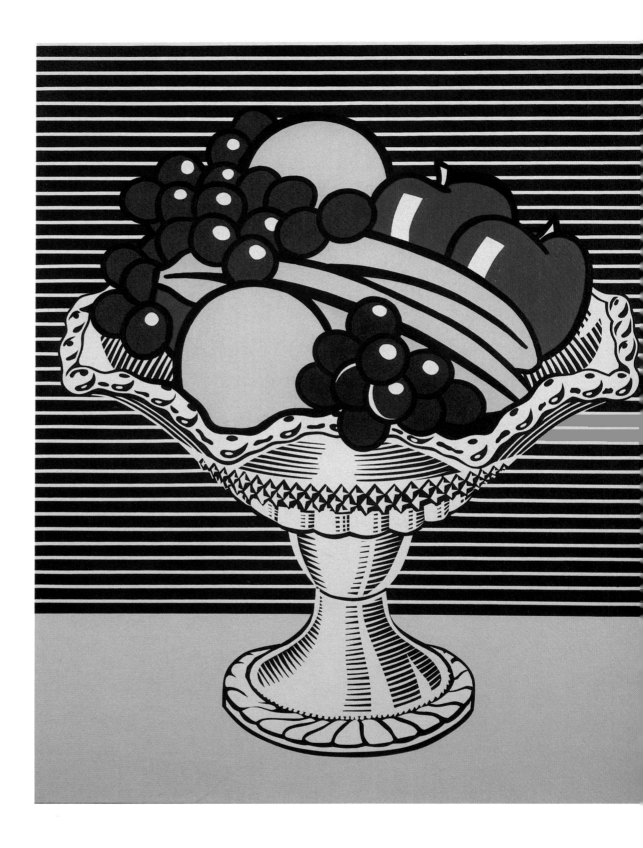

Still Life with Crystal Bowl 1973
Oil and magna on canvas
52 x 42″
Collection Whitney Museum
of American Art, New York;
Gift of Frances and Sidney
Lewis, 1977

re and Pitcher 1977
ed fabricated aluminum
10 x 24½″
ction Albright-Knox
allery, Buffalo, New York,
nd Hayes and Charles
on Funds, 1978

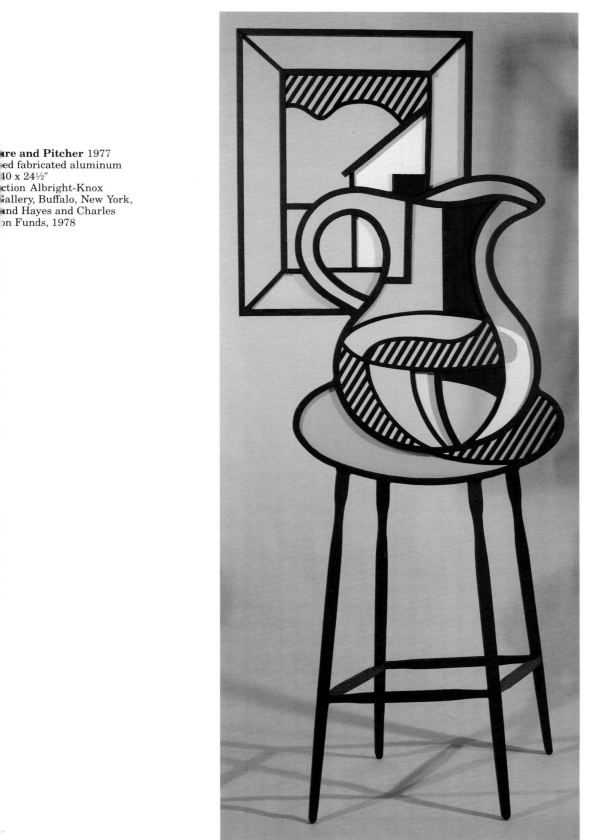

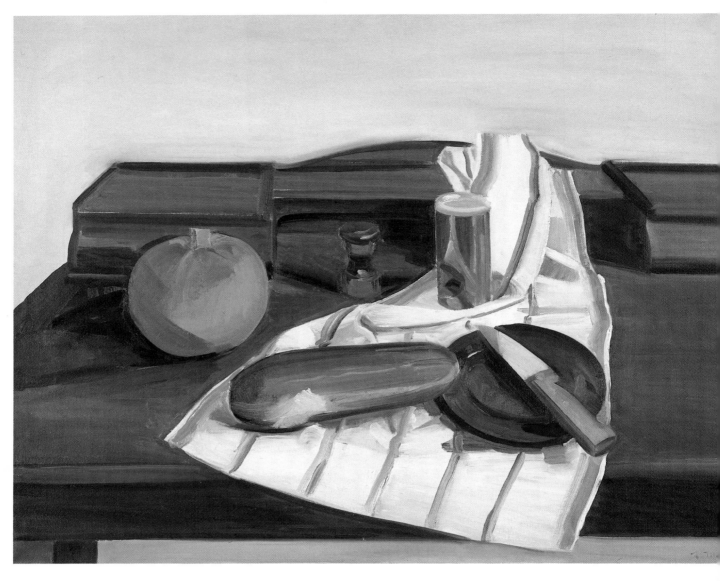

Still Life with Pumpkin 1975
Oil on canvas
28 x 36″
Courtesy Robert Schoelkopf Ga[
New York City

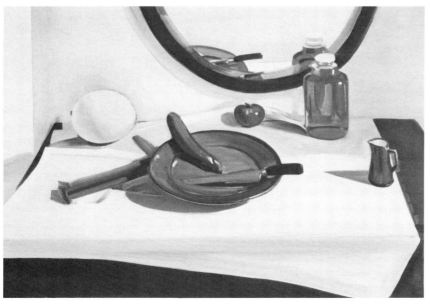

**Still Life with
Chinese Eggplants, Green Plate and Mirror**
Oil on canvas
37 x 52³⁄₁₆″
Collection The Continental Corporation,
New York City

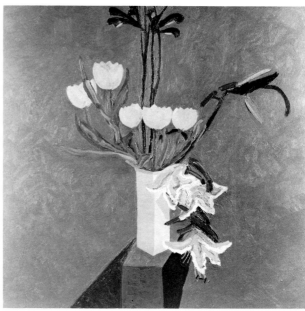

Emily 1976–81
Oil on canvas
74 x 72″
Courtesy Hirschl & Adler Modern,
New York City

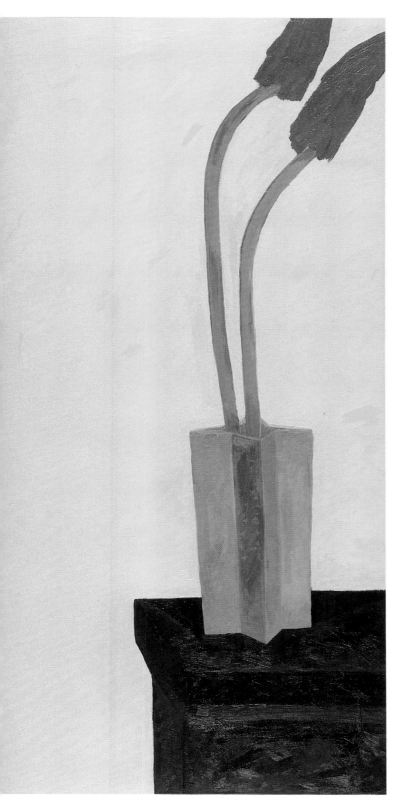

Podium 1981
Oil on canvas
84 x 42″
Courtesy Hirschl & Adler Modern,
New York City

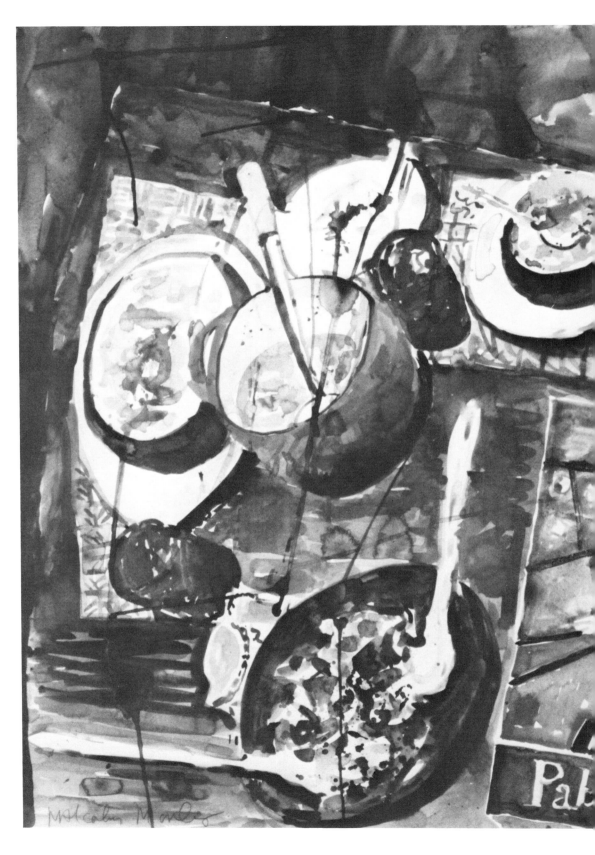

Fish Soup 1976
Watercolor on paper
30 x 22¼"
Courtesy Xavier Fourcade, Inc.,
New York City

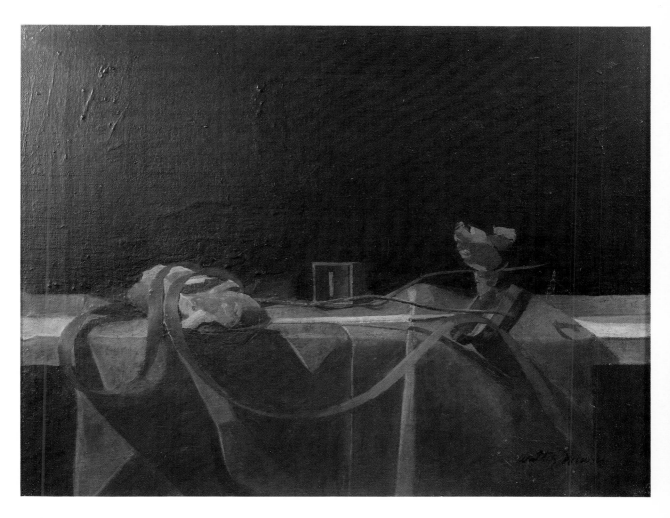

Still Life with Red Ribbon 1945
Oil on canvas
15⅛ x 19⅛″
Courtesy Sid Deutsch Gallery,
New York City

The Light 1959
Oil on canvas
15¾ x 20¾″
Collection Albright-Knox
Art Gallery, Buffalo, New York,
George Cary Fund, 1959

Still Life with Envelopes 1976
Oil on canvas
28 x 22″
The Phillips Collection,
Washington, D.C.

Bedside Still Life 1982
Oil on canvas
27 x 19″
Courtesy Xavier Fourcade, Inc.,
New York City

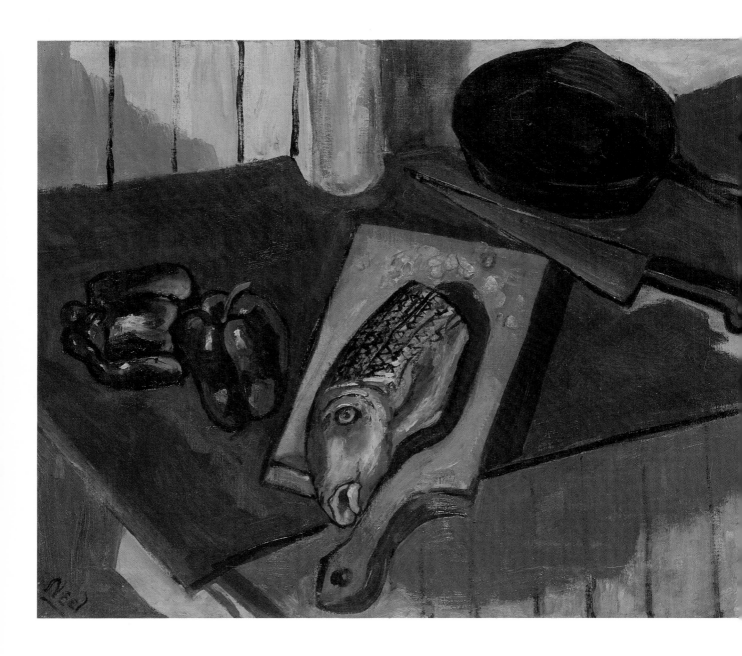

Fish Still Life 1945
Oil on canvas
18 x 22"
Courtesy Robert Miller Gallery,
New York City

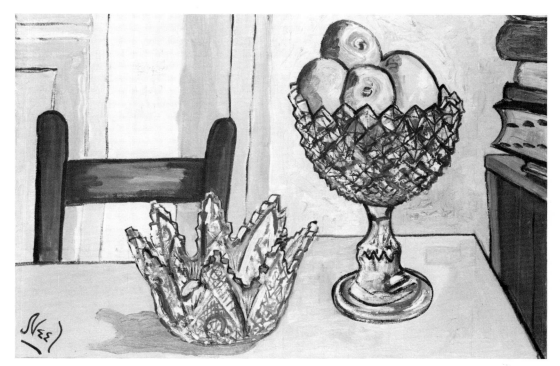

Glass with Fruit 1952
n canvas
31″
tesy Robert Miller
ery, New York City

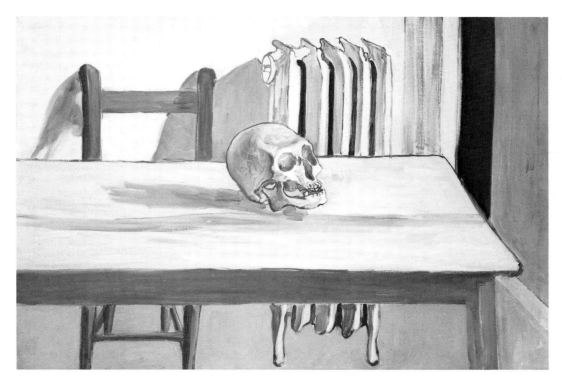

Natura Morta 1964–65
Oil on canvas
31 x 45″
Courtesy Robert Miller Gallery,
New York City

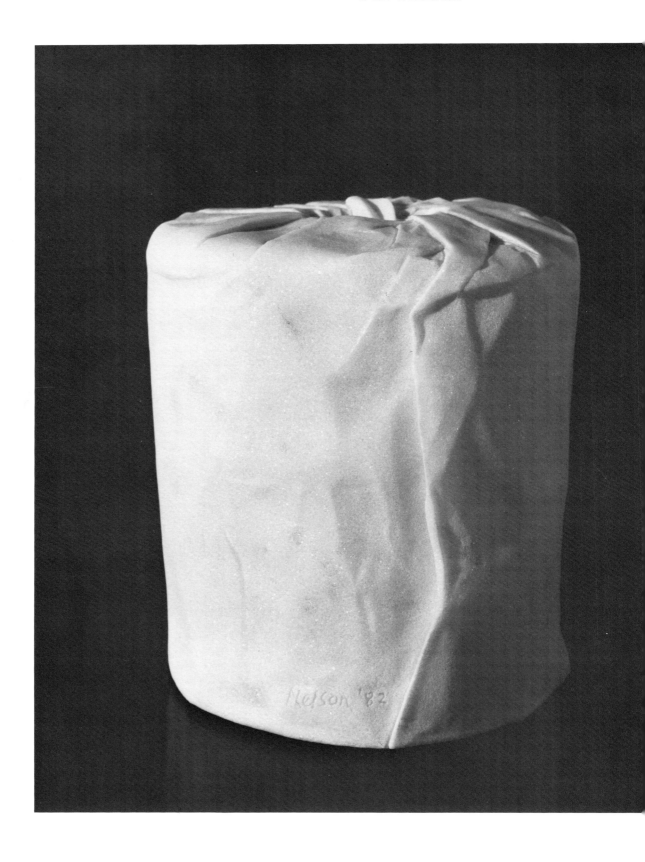

Toilet Paper #IX 1982
Carrara marble
9 x 8 x 8″
Courtesy Louis K. Meisel Gallery,
New York City

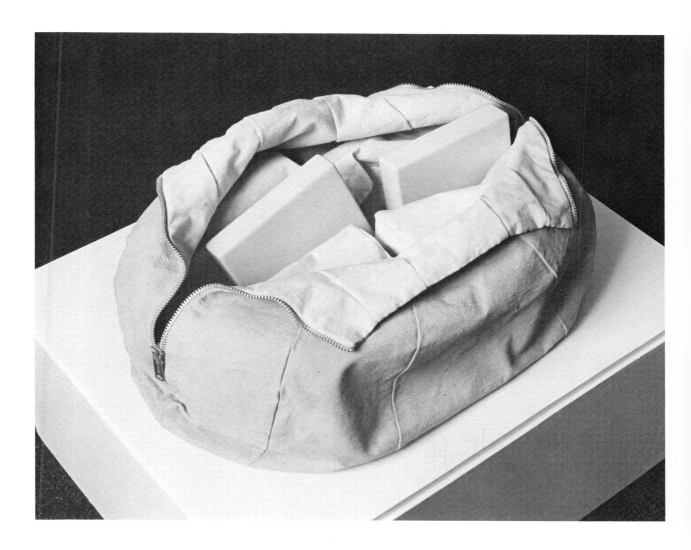

Soft Baked Potato 1970
Canvas and wood
10 x 16 x 18″
Courtesy Janie C. Lee Gallery, Houston, Texas

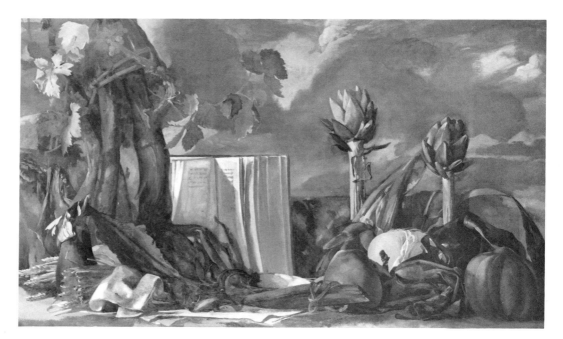

**Still Life in
Landscape** 1975
Oil on canvas
37 x 61⅝"
Courtesy Robert
Schoelkopf Gallery,
New York City

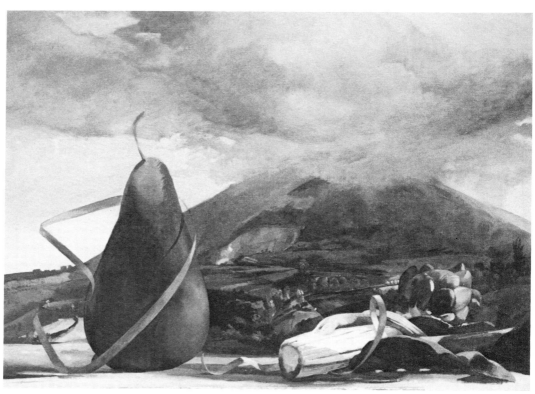

**Still Life with Mt. Acuto
in Background** 1975
Oil on canvas
27½ x 31⅜"
Courtesy Robert Schoelkopf Gallery,
New York City

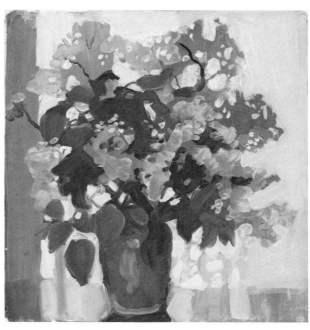

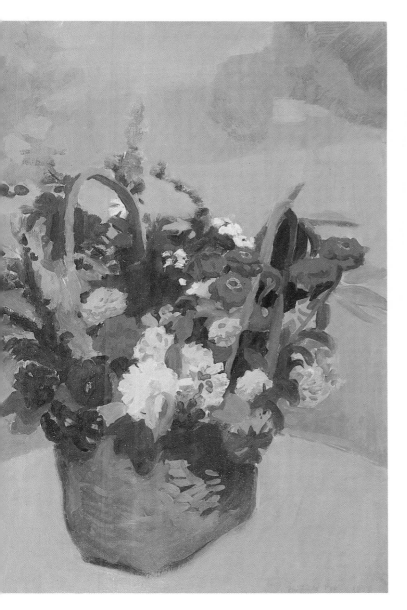

Still Life 1959
Oil on canvas
32 x 22″
Courtesy Hirschl & Adler Modern,
New York City

White Lilacs 1964
Oil on canvas
15½ x 14½″
Courtesy Gross McCleaf Gallery,
Philadelphia, Pennsylvania

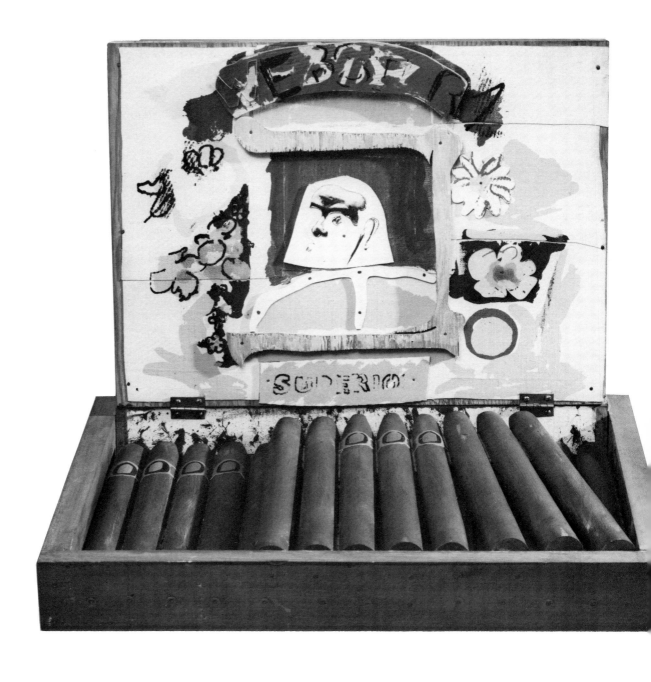

Webster and His Cigars 1964–66
Mixed media collage
on wood construction
16 x 13¼ x 13¼"
Collection Mrs. Pollard Marsters,
Houston, Texas

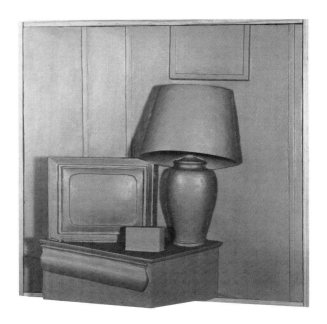

T.V. Still Life 1970
Bronze
Ed. 1/8
10¾ x 10¾ x 1½"
Collection Mr. and Mrs. Sidney Roseman
Courtesy Daniel Weinberg Gallery,
Los Angeles/San Francisco, California

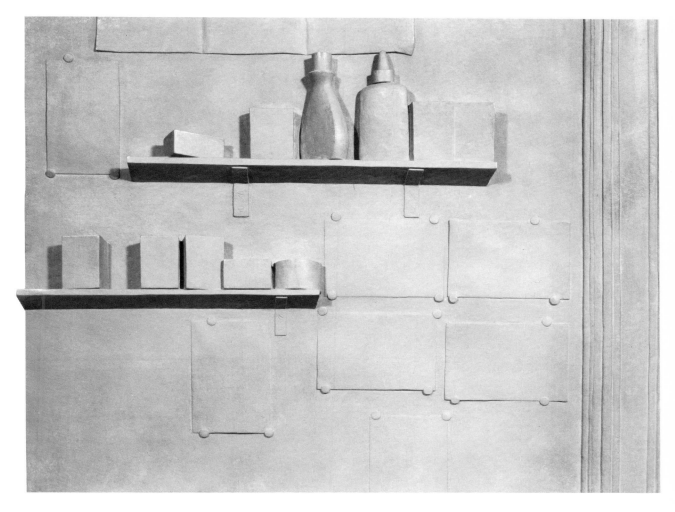

Studio Still Life 1972–73
Bronze
Ed. 1/6
12¾ x 16½ x ½"
Courtesy Daniel Weinberg Gallery,
Los Angeles/San Francisco, California

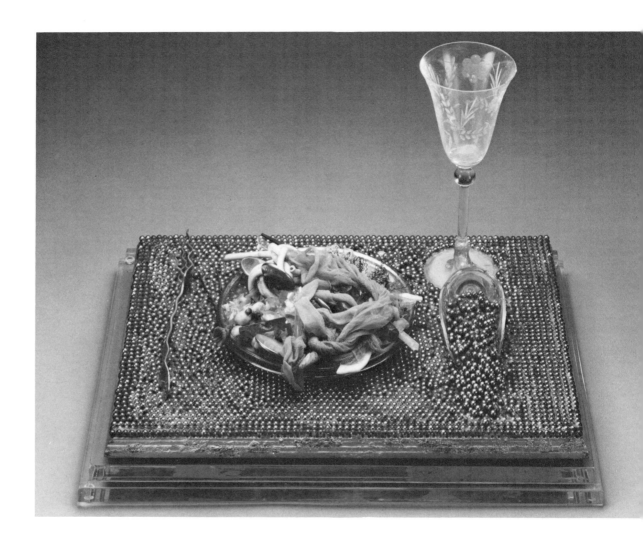

Dinner #2 1962
Mixed media
7½ x 13¾ x 9¾″
Collection The Minneapolis
Institute of Arts, Gift of
Gordon Locksley and George Shea

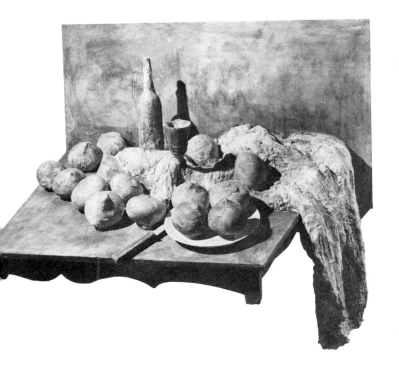

Cézanne Still Life #3 1981
Painted plaster, wood and metal
24 x 40 x 27½″
Courtesy Sidney Janis Gallery,
New York City

Still Life with Red Ball 1982
Painted plaster and wood
36½ x 17 x 9½″
Courtesy Sidney Janis Gallery,
New York City

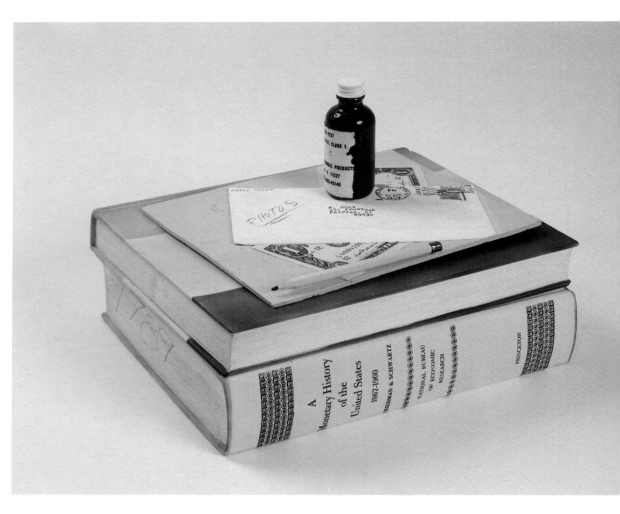

**Book Jar with Ink Bottle
and Money** 1982
Porcelain
8 x 7 x 10″
Courtesy Allan Frumkin Gallery,
New York City

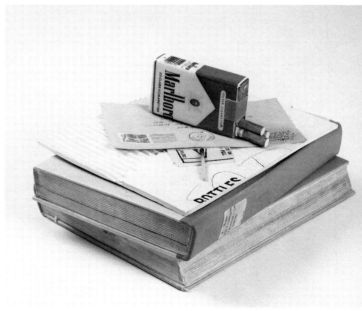

Book Jar with Cigarettes 1982
Porcelain
5 x 9¼ x 7″
Courtesy Allan Frumkin Gallery,
New York City

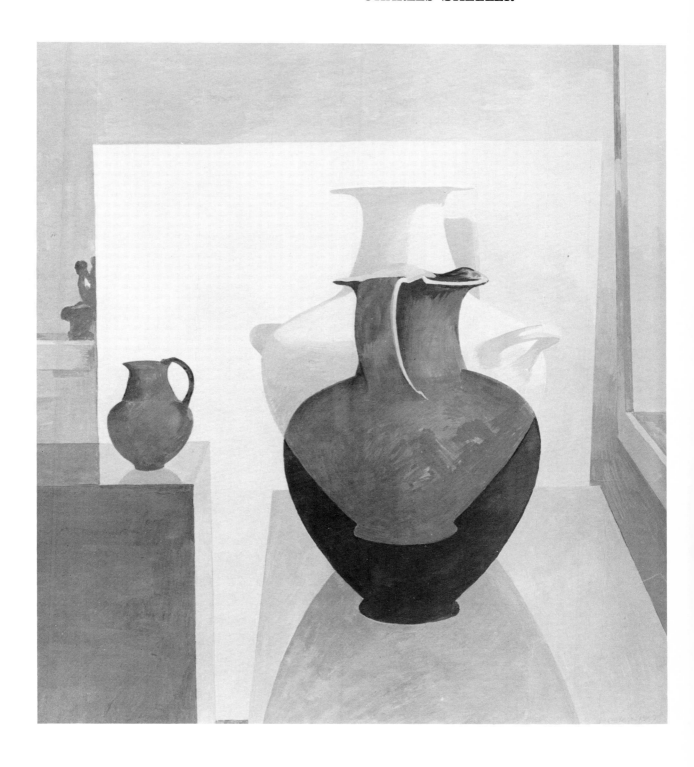

Classic Still Life 1947
Tempera on paper
15⅝ x 13½″
Collection Neuberger Museum,
State University of New York
at Purchase; gift of Roy R. Neuberger

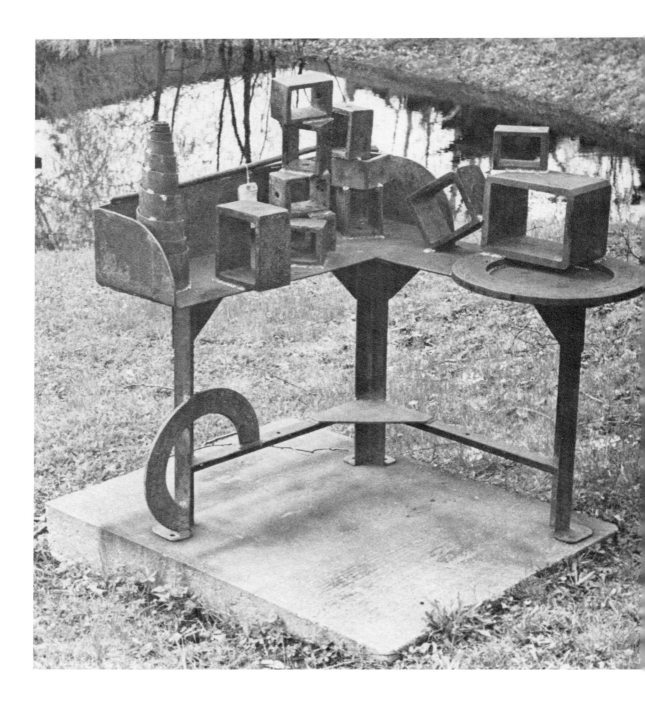

Voltri XVI 1962
Steel
44 x 40 x 38″
Collection Candida and Rebecca Smith
Courtesy M. Knoedler & Co., Inc.,
New York City

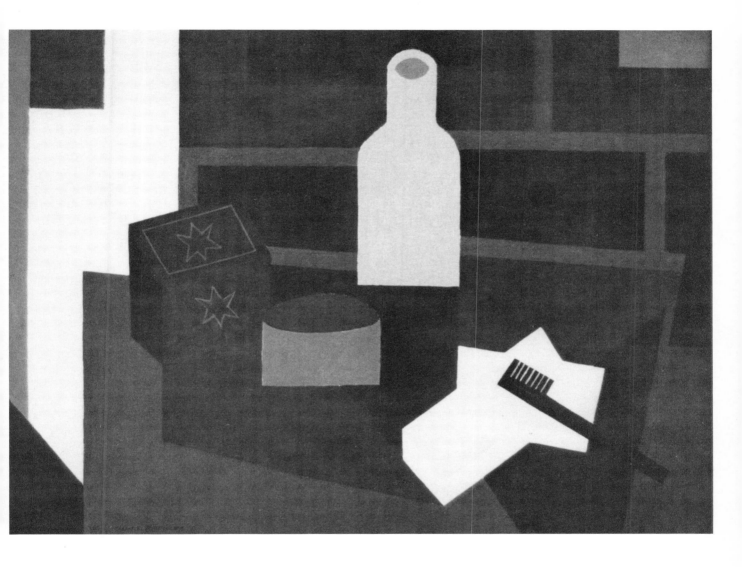

The Desk 1948
Oil on canvas
24½ x 32⅜″
Collection San Francisco Museum
of Modern Art; Gift of the
Women's Board

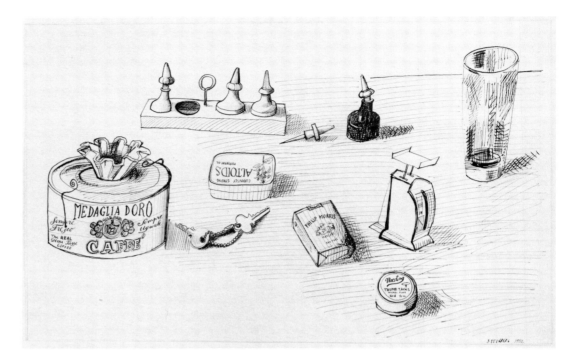

**Medaglio D'Oro Still
Life** 1952
Ink on paper
14½ x 23″
Courtesy The Pace Gallery,
New York City

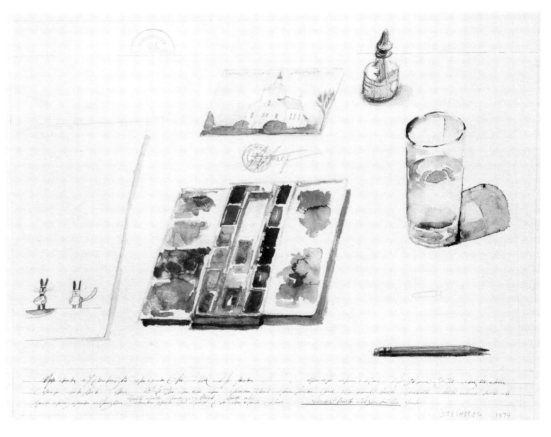

Still Life with Watercolor Set 1974
Watercolor and graphite on paper
17 x 21¾″
Courtesy The Pace Gallery,
New York City

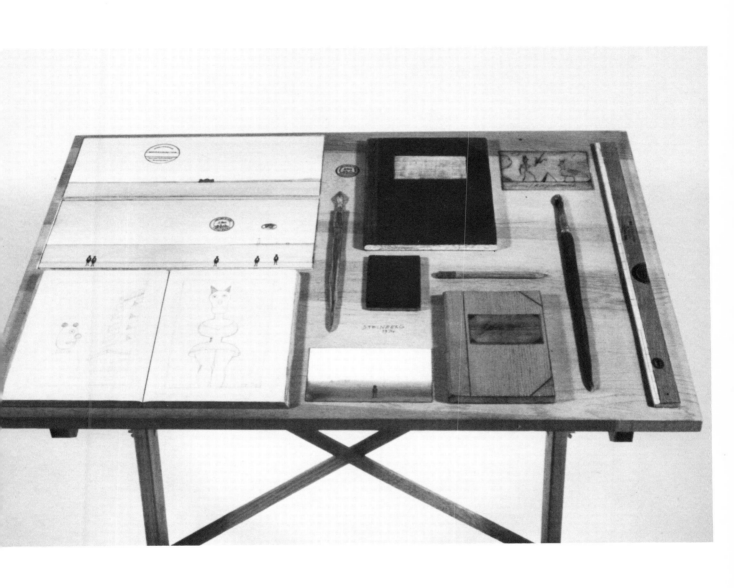

Drawing Table with Stand 1974
Collage on wood
34 x 23 x 31″
Collection Martin Z. Margulies,
Miami, Florida

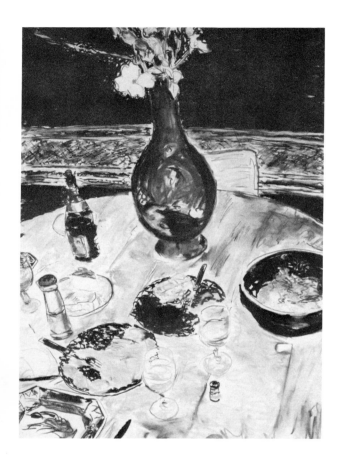

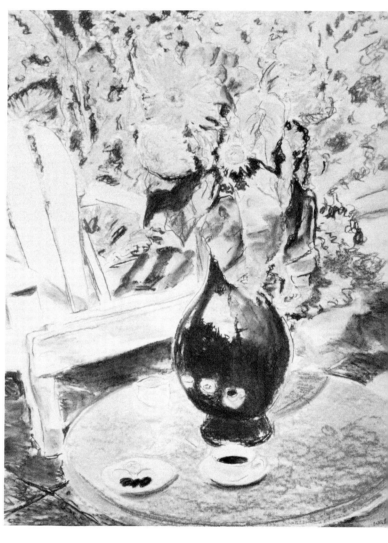

Summer Lunch with Vase 1979
Pastel on paper
43 x 30½"
Courtesy Kornblee Gallery,
New York City

Summer Breakfast 1979
Pastel on paper
41¼ x 34½"
Courtesy Kornblee Gallery,
New York City

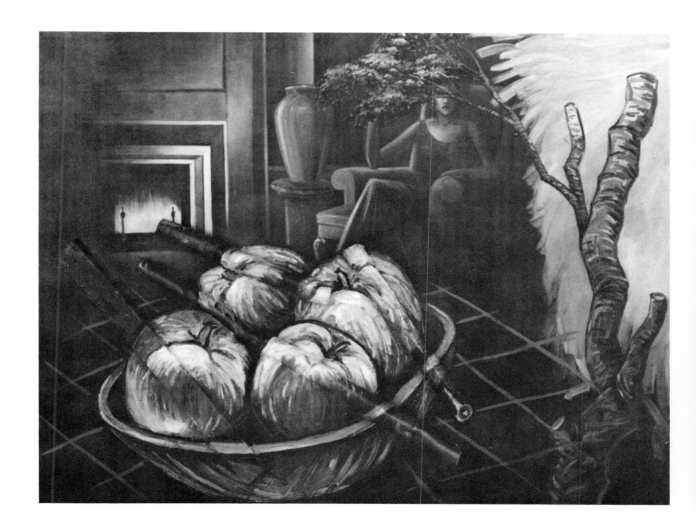

Harvest 1982
Oil over acrylic molding paste
and wood on canvas
60 x 80″
Courtesy Nancy Hoffman Gallery,
New York City

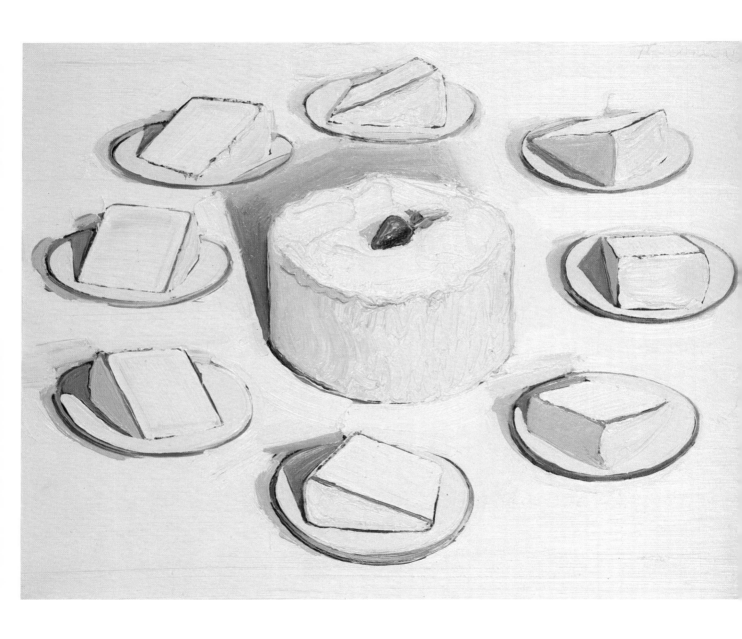

Around the Cake 1962
Oil on canvas
22 x 28″
Collection Spencer Museum of Art,
The University of Kansas;
Gift of Ralph T. Coe
in memory of Helen F. Spencer

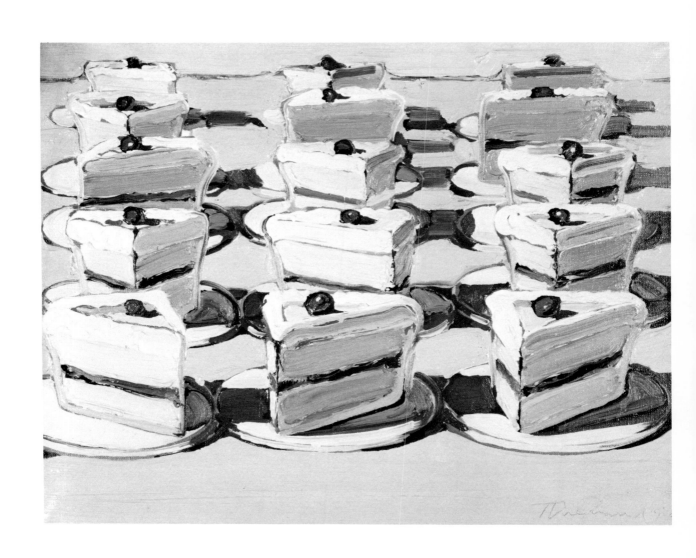

Boston Cremes 1962
Oil on canvas
14 x 18″
Collection Crocker Art Museum;
Gift of the Crocker Art
Gallery Association

Penholder Still Life 1966
Oil on canvas
19 x 24″
Collection Mrs. Muriel Tillim

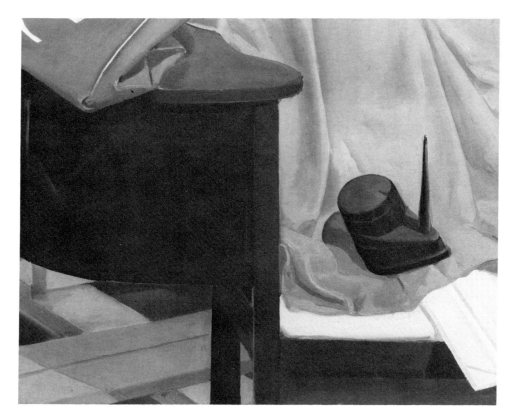

Radio and Sofa 1967
Oil on canvas
30 x 36″
Wellington Management Company/
Thorndike, Doran, Paine
& Lewis Collection

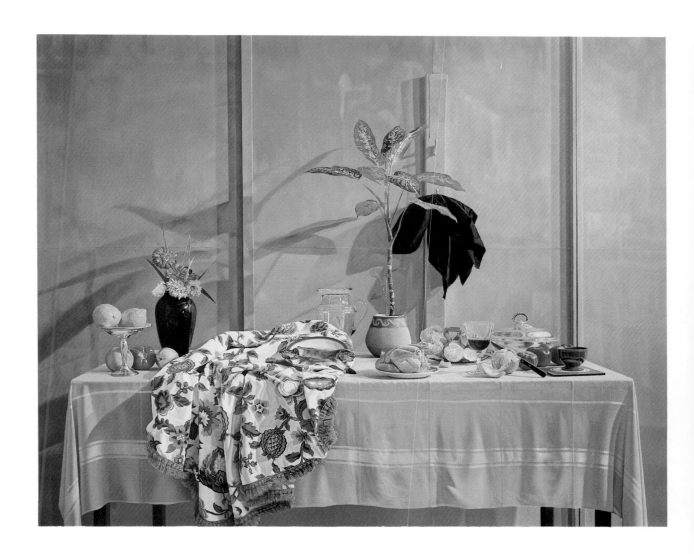

Still Life #2 1978
Oil on canvas
93½ x 116"
Collection of Graham Gund

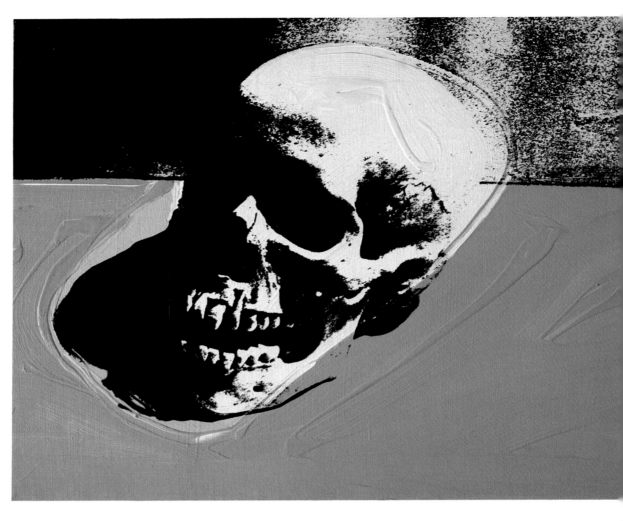

Skull 1975
Acrylic and silkscreen on canvas
15 x 19″
Collection Mr. and Mrs.
Edward R. Hudson, Jr.

Hammer and Sickle 1976
Acrylic and silkscreen on canvas
18⅞ x 15″
Courtesy Texas Gallery, Houston, Texas

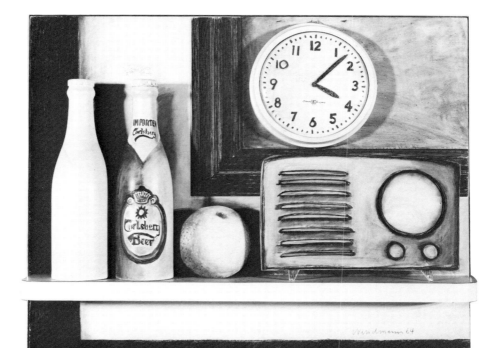

**ing 1964 for Still
No. 42** 1964
ruction
 60 x 10″
ames and Mari Michener
tion,
rcher M. Huntington
allery,
University of Texas at Austin

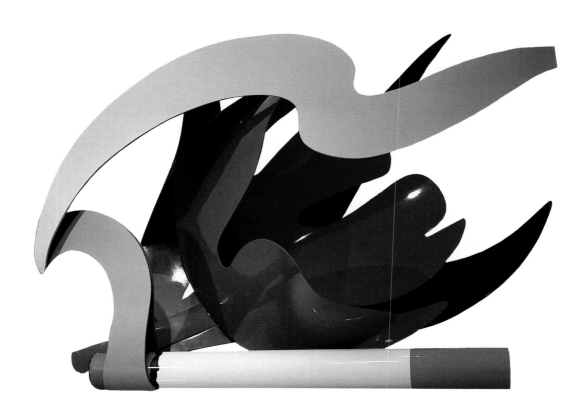

Tulip and Smoking Cigarette 1983
Painted metal
82 x 121 x 74″
Courtesy Sidney Janis Gallery,
New York City and
Delahunty Gallery, Dallas, Texas

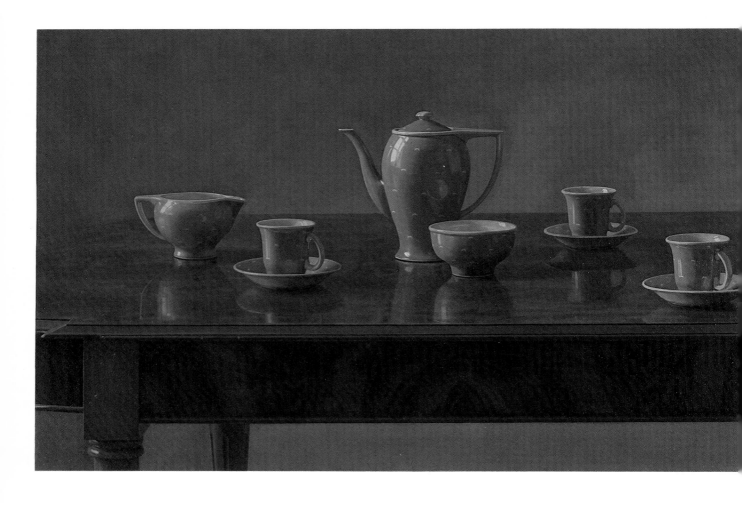

Coffee Service 1981
Oil on canvas
32 x 51″
Courtesy Robert Schoelkopf Gallery,
New York City

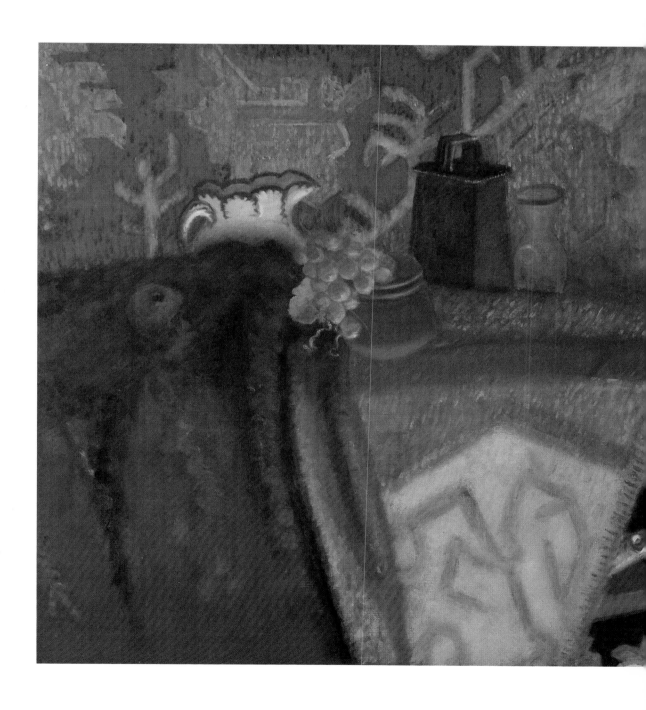

Blue Carafe 1979–81
Oil on canvas
30 x 30″
Courtesy Fischbach Gallery,
New York City

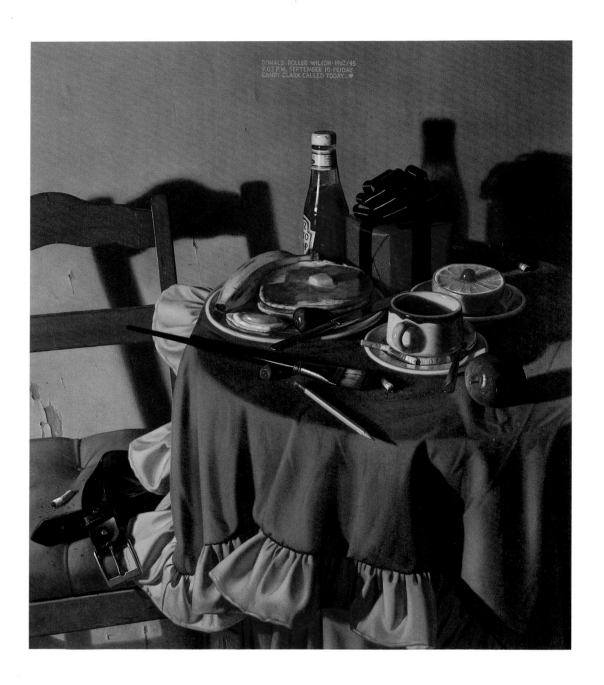

**A Pink Chair with a
Black Mans Belt** 1982
Oil on canvas
25 x 22"
Collection Charles E. Pattin,
Houston, Texas

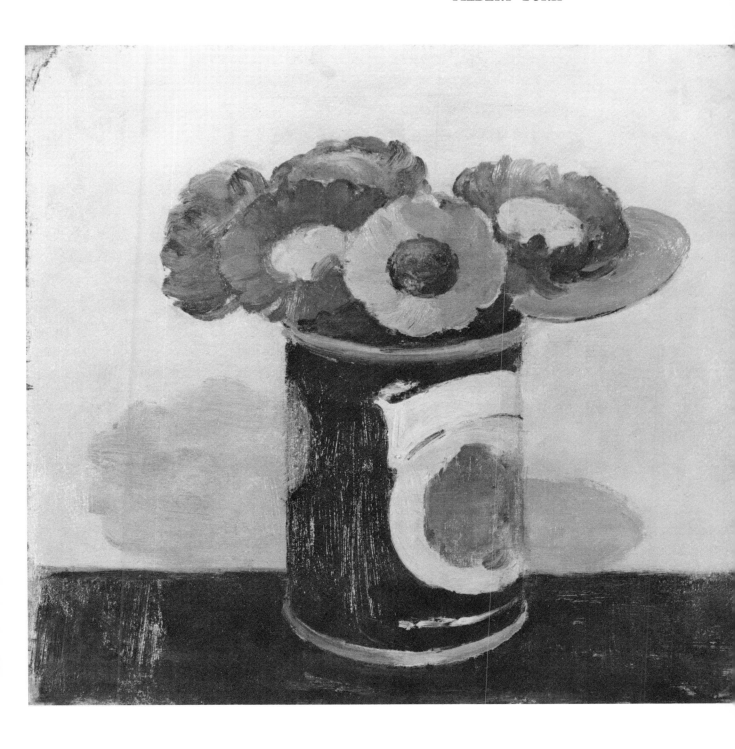

Posies in a Tin c. 1966
Oil on wood
11 x 11¾"
Courtesy Davis & Langdale
Company, Inc., New York City

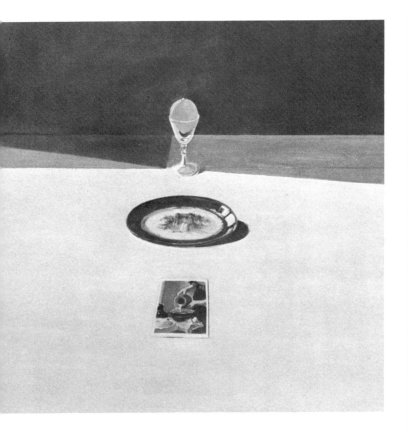

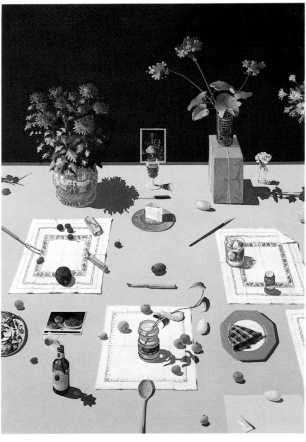

Glass, Lemon, Dish,
Postcard (Vermeer) 1968
Oil on canvas
48 x 48″
Collection Dr. and Mrs.
Lawrence Rappaport,
Davis, California

Dutch Still Life with Piece of Pie
and Piece of Cheese 1977–81
Acrylic on canvas
70 x 48″
Collection John Berggruen,
San Francisco, California

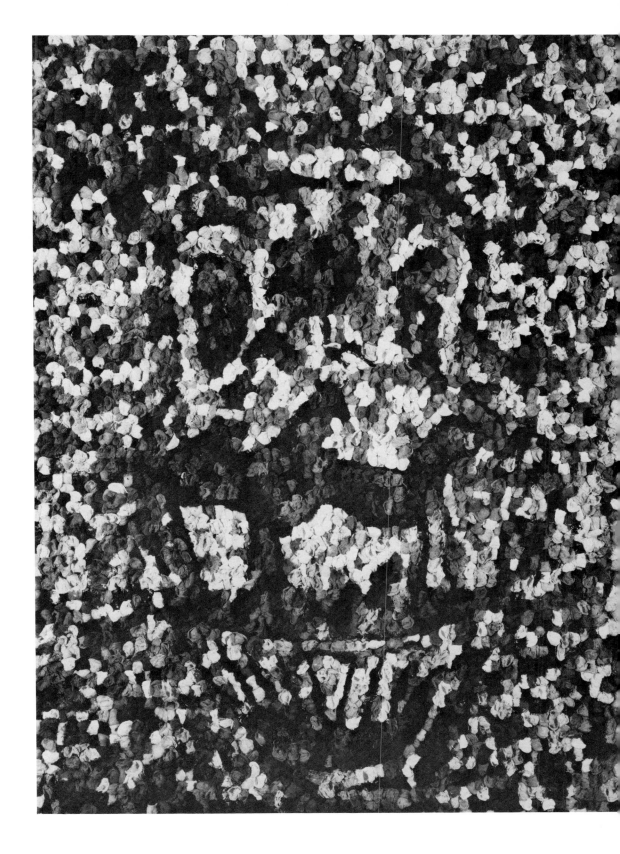

Vases 1983 (detail)
Acrylic, rhoplex and
cotton on burlap
82 x 60″
Collection The Fort Worth
Art Museum

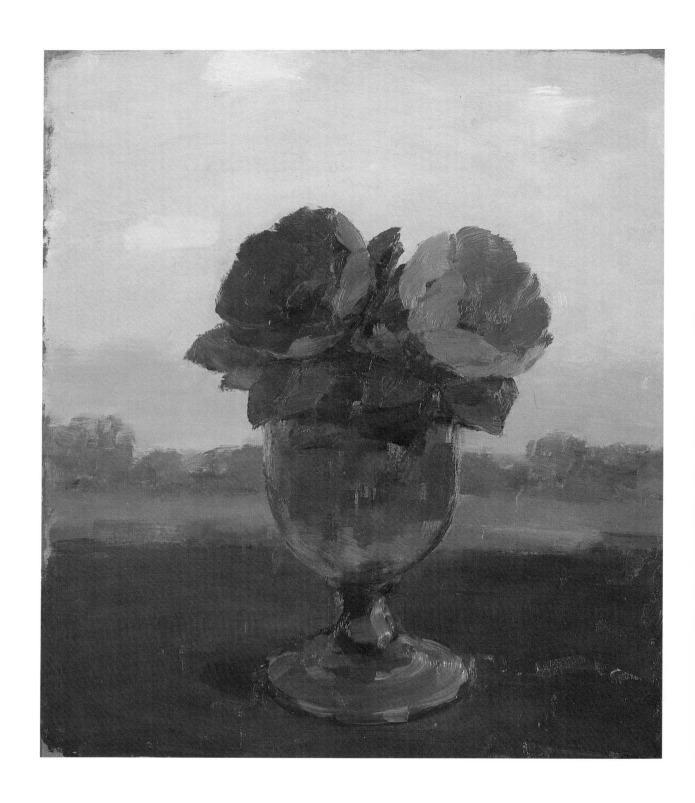

**Two Pink Anemones in a
Glass Vase in a Landscape** 1982
Oil on masonite
14 x 12½"
Collection Clifford Ross

ARTISTS' BIOGRAPHIES

The biographies are intended to highlight each artist's career and notate the major exhibitions. The information has been compiled by Emily L. Todd based on research by Darla Comeaux, Dana Friis-Hansen, Sally Gall and Jean Story.

The entries which follow each biography are intended to describe the role of still life within each artist's oeuvre.

MILTON AVERY

Born in Sand Bank, New York, in 1885, he attended the Connecticut League of Art Students, Hartford; School of the Art Society of Hartford, Connecticut, 1918–19; and the Art Students League, New York City, 1926–38. Since first included in a group show at Wadsworth Atheneum, Hartford, Connecticut, in 1915, his work has been shown at Grace Borgenicht Gallery, New York City, since 1951; The Baltimore Museum of Art, Maryland, 1952; Whitney Museum of American Art, New York City, 1960; Sheldon Memorial Art Gallery, University of Nebraska-Lincoln, 1966; National Collection of Fine Arts, Smithsonian Institution, Washington, D.C., 1969; Archer M. Huntington Art Gallery, The University of Texas at Austin, 1976; and Museo de Arte Moderno, Mexico City, 1981. The Whitney Museum of American Art, New York City, mounted a retrospective of his work in 1982. He died in New York City in 1965.

Milton Avery painted everyday subject matter—landscapes, beach scenes, interiors and the people who surrounded him. This allowed him to explore his primary interest which was the lyric interaction of broad areas of vibrant color. Through the 1940s, he painted still lifes using as his subjects the contents of his house: a telephone, a lamp or a vase of flowers on a tabletop. He knew these scenes intimately and rendered them with the same impressionistic familiarity and serenity as is found in the rest of his work.

WILLIAM BAILEY

Born in Council Bluffs, Iowa, in 1930, he attended the University of Kansas School of Fine Arts, Lawrence, 1948–51. He received his B.F.A. and M.F.A. from Yale University, New Haven, Connecticut, in 1955 and 1957 respectively. His work has been in solo exhibitions at University Art Museum, Indiana University, Bloomington, 1963; Kansas City Art Institute, Missouri, 1967; Robert Schoelkopf Gallery, New York City, since 1968; and Tyler School of Art, Temple University, Philadelphia, Pennsylvania, 1972. Since 1969, he has taught at Yale University, New Haven, Connecticut. He lives and works in New Haven, Connecticut.

William Bailey's oeuvre consists almost exclusively of large, frontal still lifes of vessels such as cups, pitchers, bowls, vases, candlesticks and eggs, although he paints an occasional portrait or interior. He paints from memory a landscape of containers, each discretely and volumetrically rendered, resting on a s tabletop set against a flat, undifferentiated ground. these paintings, he examines the subtle interaction objects of varying shapes and colors lit evenly from single light source. As one of the premier contempo rary still-life painters, his works embody the tenets classic academic still-life painting and expand upo them.

DAVID BATES

Born in Dallas, Texas, in 1952, he attended Souther Methodist University, Dallas, Texas, receiving his B.F.A. and M.F.A. in 1975 and 1977 respectively, an the Whitney Museum of American Art Independen Study Program, New York City, 1977. He has had s exhibitions at Eastfield College, Dallas, Texas, 197. 1976, 1978; Meadows Museum and Sculpture Cour Southern Methodist University, Dallas, Texas, 1978 and DW Gallery, Dallas, Texas, 1981, 1982, 1983. H lives and works in Dallas, Texas.

David Bates often takes for his subject matter his p sonal experiences and his surroundings. He is an a collector of folk-art objects which appear in his still lifes along with flowers and fish. He paints in a deli erately naive style, and this results in the canvas b coming a flat, quiltlike pattern of figures and object Bates works within a personal, narrative tradition, and his bold use of rich colors enhances an intentio ally primitive, simplistic style.

ED BAYNARD

By his own choice, little is known about the artist except that he was born in 1940 and has painted si childhood. He has had solo shows at Ivan Spence Gallery, Ibiza, Spain, in 1970; Willard Gallery, New York City, 1971–77; Alexander F. Milliken Inc., Ne York City, since 1978; John Berggruen Gallery, San Francisco, California, 1981; and Delaware Art Museum, Wilmington, 1981. He lives and works in Ne York City.

Baynard explores on paper and canvas the myriad variations resulting from the placement of flower, v and fruit set on a simple pedestal or shelf, silhouett against an anonymous ground. His calligraphic lin

Vases 1983 (detail)
Acrylic, rhoplex and
cotton on burlap
82 x 60″
Collection The Fort Worth
Art Museum

spare and clear forms, pure colors and straightforward, frontal viewpoint are used to depict the beauty, elegance and simplicity of natural forms. His avowed intent is to point out the extraordinary quality of life seen even in the midst of daily concerns.

JACK BEAL

Born in Richmond, Virginia, in 1931, he attended William and Mary College, Norfolk, Virginia, 1950–53; the Art Institute of Chicago, Illinois, 1953–56; and the University of Chicago, Illinois, 1955–56. His work has been exhibited in solo shows at Allan Frumkin Gallery, New York City and Chicago, since 1965; Galerie Claude Bernard, Paris, France, 1973, 1982; Virginia Museum of Fine Arts, Richmond, 1973; Madison Art Center, Wisconsin, 1977; and Reynolds/Minor Gallery, Richmond, Virginia, 1980. He lives and works in New York City and Oneonta, New York.

Jack Beal, since the early 1970s, has painted realist and narrative works which he would like to be a moral force in the world. His still lifes consist of objects which celebrate the positive and beautiful things of life. In them he paints common domestic scenes in a traditional style which is characteristic of the rest of his work. Beal sets up his subjects at awkward angles, and this unusual orientation combined with disconcerting lighting, produces dramatic compositions which distinguish Beal's works from more conventional realism.

THOMAS HART BENTON

Born in Neosho, Missouri, in 1889, he attended the Art Institute of Chicago, Illinois, 1906–07; and studied at the Academié Julien, Paris, France, 1908–11. His first public exhibition was at the Anderson Galleries, New York City, 1916. Retrospectives of his work have been held by Joslyn Museum, Omaha, Nebraska, 1951; New Britain Museum of American Art, Connecticut, 1954; University of Kansas, Lawrence, 1958; Graham Gallery, New York City, 1968; and the Association of American Artists, New York City, 1969. He died in Kansas City, Missouri in 1975.

Thomas Hart Benton painted abstract, geometric paintings allied with the Synchromist movement in the early part of this century. During the 1920s he began to paint representational works derived from his travels in rural and small-town America. His early training as an abstract artist gives his narrative genre scenes a monumentality and legibility of composition as he depicted both the everyday activities and the great events in the lives of Midwesteners. While Benton's still lifes and interiors are few, they display a concern for the stalwart, workaday lives of the people he painted as well as a clarity of form enhancing the communicative function of the works. In his still lifes he concentrated on a small number of objects and he gave free rein to mannerist line and rich color.

ED BLACKBURN

Born in Amarillo, Texas, in 1940, he received his B.F.A. from The University of Texas at Austin in 1962, continuing his studies at The Brooklyn Museum, New York, in 1963, and received his M.A. from the University of California, Berkeley, in 1965. His first solo exhibition at the High Plains Gallery, Amarillo, Texas, in 1959, has been followed by solo shows at the Jewish Community Center, Fort Worth, Texas, 1970; Amarillo Art Center, Texas, 1977; a collaborative exhibition sponsored by Fort Worth Art Museum, Texas and Texas Christian University, Fort Worth, Texas, 1982; and Moody Gallery, Houston, Texas, 1983. He lives and works in Fort Worth, Texas.

Ed Blackburn makes large, mixed-media works. The works of the early 1970s were painted and collaged; these have evolved into works in which he incorporates three-dimensional objects. Tables with traditional still-life arrangements of vessels and fruit are juxtaposed against paintings which use media-derived images or wallpaperlike designs and incorporate nostalgic references to times past or romantic visions.

Nell Blaine

Born in Richmond, Virginia, in 1922, she studied at Richmond Professional Institute, Virginia, 1939–42; Hans Hofmann School of Fine Arts, New York City, 1942–43; and the New School for Social Research, New York City, 1952–53. Solo exhibitions of her work have been held at Jane Street Gallery, New York City, 1945, 1948; Virginia Museum of Fine Arts, Richmond, 1947, 1955, 1973, 1979; Poindexter Gallery, New York City, 1956–76; University of Connecticut, Storrs, 1973; Fischbach Gallery, New York City, since 1979; and Jersey City Museum, New Jersey, 1981. She lives and works in New York City.

Nell Blaine was painting in a geometric and abstract style in the 1940s. In the late 1950s, she began to make still-life and landscape paintings derived from a direct observation of her subject matter. She paints casually composed still lifes of vessels, flowers, books and candles, typified by strong color, shallow depth, and gestural brushstroke. Blaine resolves her commitments to nature and to abstraction in her still lifes and landscapes by using an expressionistic style of painting to define everyday objects and scenes.

Troy Brauntuch

Born in Jersey City, New Jersey, in 1954, he received his B.F.A. from California Institute for the Arts, Valencia, in 1973. He has had solo shows at The Kitchen, New York City, 1979; Metro Pictures, New York City, 1981; and Mary Boone Gallery, New York City, 1982, 1983. He lives and works in New York City.

Troy Brauntuch chooses the imagery for his works from secondary sources such as the media. His still lifes are often derived from photographs of the interiors of traditional studios, seemingly abandoned, which contain only artist's tools, plaster models and furniture. While Brauntuch's subject matter is traditional, his obfuscation of the image and source material bestow a more modern sense of power, monumentality and mystery to his large, often multi-paneled works.

Vija Celmins

Born in Riga, Latvia, in 1939, she came to the United States in 1949. She received her B.F.A. in 1962 from John Herron Art Institute, Indianapolis, Indiana, and her M.F.A. from University of California, Los Angeles in 1965. Her work has been shown in solo exhibitions at David Stuart Galleries, Los Angeles, California, 1966; Riko Mizuno Gallery, Los Angeles, California, 1970, 1973; Whitney Museum of American Art, New York City, 1973; and David McKee Gallery, New York City, 1983. Newport Harbor Art Museum, Newport Beach, California, organized a retrospective exhibit of her work in 1979. She lives and works in New York City and Venice, California.

Vija Celmins is best known for her graphite drawings based on photographs of ocean, lunar and desert surfaces and other natural phenomena. In the early 1960s, she made several still lifes, usually of single objects, rendered with the same meticulous, precise process which characterizes her other work. They consist of centered images—a lamp, a television, a hot plate, a heater—on ambiguous backgrounds. She eliminated the need for composition by the use of a single object, and these paintings with their isolated objects are a prelude to qualities of stillness and isolation found in her later work.

Robert Colescott

Born in Oakland, California, in 1925, he received his B.A. and M.A. from the University of California, Berkeley, in 1949 and 1952 respectively and attended Atelier Fernand Léger, Paris, France, 1949–50. He had solo exhibitions at Miller Pollard, Seattle, Washington, 1953, 1954; Portland Art Museum, Oregon, 1958, 1969; The Fountain Gallery of Art, Portland, Oregon, 1960, 1966, 1972; Reed College, Portland, Oregon, 1961; Salem Art Museum, Massachusetts, 1961; Victoria Art Gallery, British Columbia, Canada, 1965; Razor Gallery, New York City, 1975, 1977; John Berggruen Gallery, San Francisco, California, 1975, 1978; and Semaphore Gallery, New York City, since 1980. He lives and works in Oakland, California.

Robert Colescott's paintings combine seemingly lowbrow, bawdy humor and extremely sophisticated statements about art-world conventions and black,

ethnic stereotypes. He parodies these clichés in narratives depicted in heightened color, raucous motion and purposely "bad" style. His small still lifes are submitted to this same caustic, intellectual examination.

MARY ANN CURRIER

Born in Louisville, Kentucky, in 1927, she attended Chicago Academy of Fine Art, Illinois, 1945–48, and University of Louisville, Allen R. Hite Art Institute, Kentucky, where she received her M.F.A. in 1962. She has had solo shows at Byck Gallery, Lexington, Kentucky, 1977, 1980; Bellarmine College, Louisville, Kentucky, 1978; Brescia College, Owensboro, Kentucky, 1980; and the Actors Theater, Louisville, Kentucky, 1980. Her work has been included in a group show at Alexander F. Milliken Inc., New York City, 1982. She lives and works in Jacksonville, Florida.

Mary Ann Currier paints foodstuffs, tableware and kitchen utensils. In her still lifes, she often juxtaposes cookware with a translucent onion or mottled avocado in order to portray the resultant interplay of light, shadow and reflection. She captures the precise texture, weight, luminescence and individuality of each object in domestic still lifes.

RICHARD DIEBENKORN

Born in Portland, Oregon, in 1922, he attended Stanford University, Palo Alto, California, 1940–43, 1948–49, receiving his B.F.A. in 1949 and the University of New Mexico, Albuquerque, receiving his M.F.A. in 1951. Since his first solo exhibition at the Palace of the Legion of Honor, San Francisco, California, in 1948, he had a second major exhibition there in 1960 as well as exhibitions at Pasadena Art Museum, California, 1960; Paul Kantor Gallery, Los Angeles, California, 1952, 1954; Poindexter Gallery, New York City, 1956–71; The Phillips Collection, Washington, D.C., 1961; Los Angeles County Museum of Art, California, 1969; San Francisco Museum of Art, California, 1972, 1983; Marlborough Gallery, New York City,

London, England and Zürich, Switzerland, 1971–75; and M. Knoedler & Co., Inc., New York City, since 1977. The Albright-Knox Art Gallery, Buffalo, New York, mounted a retrospective of his work in 1976. He lives and works in Santa Monica, California.

Richard Diebenkorn made abstract paintings until the mid-1950s when he, along with several other Bay Area painters, rejected this style in favor of representational painting. He painted still lifes from 1955 to 1963. In these paintings, he places conventional still-life subjects such as fruit, knives, glassware and studio tools in angular configurations on tabletops. The paintings contrast the flat abstraction of the tipped-up tabletop plane with the realism of three-dimensional objects. Diebenkorn is best known for a series of abstract paintings entitled *Ocean Park* begun in 1965 which continues to demonstrate his concern with atmosphere and the interaction and meeting of planes in space.

LINDA ETCOFF

Born in Brookline, Massachusetts, in 1952, she attended Rhode Island School of Design, Providence, 1970–71 and the School of the Museum of Fine Arts, Boston, Massachusetts, receiving her B.F.A. in 1975. She has had solo shows at Harcus/Krakow Gallery, Boston, Massachusetts, 1979, 1983. She lives and works in Boston, Massachusetts.

Linda Etcoff's paintings are occasionally still lifes, characterized by a play on art-historical references. Although they at first appear to be traditional in appearance, they are both visually and intellectually eccentric. Elements are placed on tabletops, in a seemingly random fashion, to express paradox which is enhanced by the incorporation of images by other artists. All of the elements are rendered with absolute precision. Etcoff ingeniously emphasizes the disparity between the traditional appearance and unconventional content in her works.

Manny Farber

Born in Douglas, Arizona, in 1917, he attended University of California, Berkeley, 1934; Stanford University, Palo Alto, California, 1935; and California School of Fine Arts, San Francisco, 1936. Solo shows of his work have been held at Tibor de Nagy Gallery, New York City, 1956, 1957; O. K. Harris Works of Art, New York City, 1970–77; Institute for Art and Urban Resources, P.S. 1, Long Island City, New York, 1978; Oil and Steel Gallery, New York City, 1982; and Larry Gagosian Gallery, Los Angeles, California, 1983. The La Jolla Museum of Art, California, mounted a retrospective of his work in 1978. He has taught at University of California, San Diego, since 1970 and writes film criticism for several publications. He lives and works in Leucadia, California.

Manny Farber has worked in a variety of styles. He has made abstract paintings on collaged paper, sculpture from salvaged materials, and most recently representational thematic paintings that incorporate still-life elements. Initially these paintings were of food, candy wrappers, cigarettes, brushes and inkwells simply depicted in a painterly yet realistic manner. In his increasingly complex paintings, Farber works in a tondo format creating a visual and narrative rhythm by using disparate scale for different objects and by incorporating a treasure-hunt narrative, laden with double-entendre and cinematic references.

Eric Fischl

Born in New York City in 1948, he received a B.F.A. from California Institute of the Arts, Valencia, in 1972. He has had solo shows at Dalhousie Art Gallery, Halifax, Nova Scotia, Canada, 1975; Edward Thorp Gallery, New York City, 1980, 1981, 1982; Sable-Castelli Gallery, Ltd., Toronto, Ontario, Canada, 1981, 1982; and University of Colorado Art Museum, Boulder, 1982. He lives and works in New York City.

Eric Fischl is primarily a painter of figures and narrative scenes, but his few still-life paintings contain the same sense of disassociation and imminent psychological or physical shock that is present in his other works. His still lifes are set in interiors. They contain modern objects such as telephones, televisions and newspapers arranged in a casual manner suggesting an observed slice-of-life narrative similar to that found in his figurative canvases.

Janet Fish

Born in Boston, Massachusetts, in 1938, she received her B.A. in Fine Arts from Smith College, Northampton, Massachusetts, in 1960, and her B.[...] and M.F.A. from Yale University, New Haven, Connecticut, in 1963. She has had solo exhibitions at Kornblee Gallery, New York City, 1971–76; The Pa[...] Gallery, New York City, 1972; Galerie Alexandra M[...]ett, Brussels, Belgium, 1974; Tolarno Gallery, Melbourne, Australia, 1975, 1977; University of New Y[...] at Stony Brook, 1976, 1978; Robert Miller Gallery, New York City, since 1978; and the Delaware Art M[...]seum, Wilmington, 1982. She lives and works in N[...] York City.

Janet Fish paints arrangements of glassware, flow[...] food and fruit, usually set on tabletops or ledges, t[...] emphasize the play of light on reflective surfaces. [...] her early works all the objects are chosen for their quality of reflection and refraction. Recent works a[...] less concerned with the spectacle of light than with the composition of still life in a more traditional m[...] expanding subject matter to include commercial pr[...]ucts, magazines and an occasional figure. These w[...] are still informed by a sophisticated and distinctiv[...] luminosity, and Fish remains one of the most focus[...] of contemporary still-life painters.

Audrey Flack

Born in New York City in 1931, she graduated from Cooper Union, New York City, in 1951, and receive[...] B.F.A. from Yale University, New Haven, Connectic[...] in 1952. She has had solo exhibitions at Roko Galle[...] New York City, 1959, 1963; French and Co. Gallerie[...] New York City, 1972; Louis K. Meisel Gallery, New York City, since 1974; and the University of South Florida Art Galleries, Tampa, 1981. She lives and works in New York City and East Hampton, New York.

Audrey Flack has worked almost exclusively in sti[...] life for the past ten years. She uses traditional still life subject matter such as fruit, food, flowers and glassware, as well as feminine paraphernalia such[...] makeup jars, jewelry, bottles of perfume and nail p[...]ish. The objects depicted are larger than life, crowd[...] the picture plane, and intensified by bright color ar[...] glistening reflections. Flack's kaleidoscopic groupin[...] frequently allude to transient pleasures.

ALICE FORMAN

Born in New York City in 1931, she received her B.A. from Cornell University, Ithaca, New York, and continued her studies at the Art Students League, New York City. She has had solo shows at Camino Gallery, New York City, 1960, 1962; Phoenix Gallery, New York City, 1966–76; Marist College, Poughkeepsie, New York, 1965, 1968, 1973; and Kornblee Gallery, New York City, since 1977. She lives and works in Poughkeepsie, New York.

Alice Forman's paintings of the 1950s are heavily textured and abstract. In the 1960s, she began the current body of work in which she portrays domestic interiors, including still life and figures. She uses shallow space to create an arena for dense arrangements of household objects, flowers and fabric, creating a patchwork of objects and drapery reminiscent of busy Victorian taste. Forman's use of rich colors and patterns produces a flat, abstract and decorative quality in her paintings.

JANE FREILICHER

Born in New York City in 1924, she received her B.A. from Brooklyn College, New York; her M.A. from Columbia University, New York City; and continued her studies at Hans Hofmann School of Fine Arts, Provincetown, Massachusetts. She has had solo exhibitions at Tibor de Nagy Gallery, New York City, 1952–74; Fischbach Gallery, New York City, since 1975; Wadsworth Atheneum, Hartford, Connecticut, 1976; Utah Museum of Fine Arts, Salt Lake City, 1979; and College of the Mainland, Texas City, Texas, 1982. She lives and works in New York City.

Jane Freilicher paints interior still lifes framed by windows through which are seen broad expanses of landscape. These works are characterized by a direct observation of nature and the play of sparkling light across the subject matter. Like other painters of her generation, Freilicher is strongly influenced by Abstract Expressionism, while keeping to the tradition of realistic depiction of subjects including interiors and landscapes.

ALBERT EUGENE GALLATIN

Born in Villanova, Pennsylvania, in 1882, he attended New York Law School, New York City, in the early 1900s. His work has been exhibited at Galerie Pierre, Paris, France, in 1938 and in solo shows at Willard Gallery, New York City, 1941 and Zabriskie Gallery, New York City, 1972. He founded The Museum of Living Art in 1927 at New York University, New York City. He wrote articles for art periodicals, a book entitled *Modern Art at Venice and Other Notes* and monographs on Braque, Demuth, Gris, Lachaise, Marin, Miró, Vermeer and others. He died in 1952 in New York City.

Albert Eugene Gallatin saw himself as a patron of the arts and is best known as an early collector of modernist work. His paintings are an outgrowth of his interest in Cubism and Constructivism. Many of his still lifes are of studio implements, food and flowers on tables as he felt these objects were ideal subject matter for the analytic breaking up and re-creating of form. Gallatin's still lifes are composed of simplified, geometric forms, overlapping and tipped-up planes, an even and apparent brushstroke and the occasional incorporation of collage.

JEDD GARET

Born in Los Angeles, California, in 1955, he studied at Rhode Island School of Design, Providence, and the School of Visual Arts, New York City. Solo exhibitions of his work have been held at Robert Miller Gallery, New York City, since 1979; Galerie Bischofberger, Zürich, Switzerland, 1980; John Berggruen Gallery, San Francisco, California, 1982; and Texas Gallery, Houston, Texas, 1982. He lives and works in New York City.

Jedd Garet's paintings depict amorphous figures and still-life objects in undefined landscapes or classical architectural settings. He renders his subjects with a flat, simple, broad brushstroke, indicating volume through shading which emphasizes the object's silhouette. His distinct and reductive style as well as his placement of objects on classical pedestals cause these objects to seem adrift in surreal surroundings. This sensation is often enhanced by Garet's use of high-keyed colors and shaped canvases.

GREGORY GILLESPIE

Born in Elizabeth, New Jersey, in 1936, he attended Cooper Union, New York City, 1954–60 and San Francisco Art Institute, California, where he received his B.F.A. in 1962 and his M.F.A. in 1963. He has had solo shows at Forum Gallery, New York City, since 1966; Hirshhorn Museum and Sculpture Garden, Smithsonian Institution, Washington, D.C., 1977; and John Berggruen Gallery, San Francisco, California, 1983. He lives and works in Easthampton, Massachusetts.

Gregory Gillespie paints portraits and his studio surroundings with such exactitude that they become hyperreal. His attention to minute details and his ability to paint the texture of each object with absolute fidelity give his work iconographic associations. In the still lifes, domestic objects and food are accompanied by images of other artists' works. The pictures have many symbolic elements although Gillespie has said his intention is to represent what he sees simply and directly.

RALPH GOINGS

Born in Corning, California, in 1928, he received a B.F.A. from California College of Arts and Crafts, Oakland, in 1953 and a M.A. from Sacramento State College, California, in 1966. He has had solo shows at Artists Cooperative Gallery, Sacramento, California, 1960, 1962; Artists Contemporary Gallery, Sacramento, California, 1968; and at O. K. Harris Works of Art, New York City, since 1970. He lives and works in Charlottesville, New York.

Ralph Goings' major work is a series of paintings of trucks. For his still-life works, he also takes the commonplace as his subject, painting napkin dispensers, salt and pepper shakers or condiment containers on formica tabletops. As the pickup truck signifies a certain attitude and represents working-class America, the still lifes also stand for a certain way of life. These pictures are painted precisely and dispassionately, with fidelity to the subjects and their settings.

MORRIS GRAVES

Born in Fox Valley, Oregon, in 1910, he received no formal art education. Since his first solo show at Seattle Art Museum, Washington, in 1936, retrospectives of his work have been held at the California Palace of the Legion of Honor, San Francisco, 1948; Beaumont Art Museum, Texas, 1952; Whitney Museum of American Art, New York City, 1956; The Pavilion Gallery, Balboa, California, 1963; and University of Oregon Museum of Art, Eugene, 1966. His work has been shown at Willard Gallery, New York City, since 1942, and Foster-White Gallery, Seattle, Washington, since 1975. The Phillips Collection, Washington, D.C., organized a retrospective of his work in 1983. He lives and works in Loleta, California.

Morris Graves' involvement with Eastern philosophical and spiritual attitudes is an essential component of his works. In the 1970s he began a series of paintings of floral arrangements. These lyrical still lifes are each keyed to a particular season of the year through identifiable flora and his use of color and lighting. Atmospheric paintings, like his well-known bird pictures, are subtly colored, and their backgrounds lack atmosphere and definition. The proportion and arrangement of the bouquets reflect Graves' search for form which would convey mood.

PHILIP GUSTON

Born in Montreal, Canada, in 1913, he studied at Otis Art Institute, Los Angeles, California, 1930–31. Since his first exhibition at Stanley Rose Gallery, Los Angeles, California, in 1931, his work has been seen in exhibitions at Sidney Janis Gallery, New York City, 1956, 1958, 1959, 1961; The Solomon R. Guggenheim Museum, New York City, 1962; Rose Art Museum, Brandeis University, Waltham, Massachusetts, 1966; David McKee Gallery, New York City, since 1974; at The Whitechapel Art Gallery, London, England, 1982. The San Francisco Museum of Modern Art, California, mounted a retrospective of his work in 1980. He died in Woodstock, New York, in 1980.

In 1970, Philip Guston's work shifted from atmospheric Abstract Expressionism to a unique kind of representation. Guston united two fundamental concepts in twentieth-century art: the veracity of real objects in

discernible spaces and Abstract Expressionist theory and process. The resultant still-life paintings of everyday objects—such as shoes, bottles, cigars, brushes, easels and cans—which surrounded him in his studio and home, are symbolic and autobiographical.

HANS HOFMANN

Born in 1880 in Weissenburg, Bavaria, Germany, he studied at the Académie de la Grande Chaumière, Paris, France, 1904. He moved to the United States in 1932. After his first exhibition at Paul Cassirer Gallery, Berlin, Germany, in 1910, he had solo shows at Art of This Century, New York City, 1944; Kootz Gallery, New York City, 1947–66; Andre Emmerich Gallery, New York City, since 1967; Waddington Galleries, London, England, 1970, 1973; and retrospective exhibitions at the Addison Gallery of American Art, Andover, Massachusetts, 1948; Whitney Museum of American Art, New York City, 1957; and The Museum of Modern Art, New York City, 1963. The Hirshhorn Museum and Sculpture Garden, Smithsonian Institution, Washington, D.C. and The Museum of Fine Arts, Houston, Texas, co-sponsored a retrospective of his work in 1976. He died in 1966 in New York City.

Hans Hofmann is well-known as a teacher, a theorist and a painter. He founded schools in Munich, Germany; New York City; and Provincetown, Massachusetts. Although best known for his completely abstract canvases, he made works into the mid-1950s that contained recognizable objects such as those found in the still-life *Fruit Bowl* series. As in his abstract pictures, his choice of color, placement of forms and use of line reflected Hofmann's theories of the interaction and consequent apparent progression and regression of colors from the actual painting plane.

NEIL JENNEY

Born in Torrington, Connecticut, in 1945, he attended Massachusetts College of Art, Boston, 1964–66. He has had solo shows at Gallery Rudolf Zwirner, Cologne, West Germany, 1968; Richard Bellamy/Noah Goldowsky Gallery, New York City, 1970; David Whitney Gallery, New York City, 1970; 98 Greene Street Loft, New York City, 1973; Blum/Helman

Gallery, New York City, 1974; and Wadsworth Atheneum, Hartford, Connecticut, 1975. The University Art Museum, University of California, Berkeley, mounted a retrospective of his work in 1981. He lives and works in New York City.

Neil Jenney's work from 1966–69 consists of sculptural pieces composed of found objects in bizarre juxtapositions. He began to paint in 1968, placing related objects and people on a field of brushstrokes. The juxtaposition of objects is enhanced by a visual and verbal relationship defined by the artist in the work's title which he paints on the frame and considers integral to the piece. These still lifes of larger-than-life-size objects rest uneasily in their isolation. Jenney sees himself as a realist, but his emphasis on the witty conjunction of everyday objects, actions and words also allies him with Pop art.

JASPER JOHNS

Born in Augusta, Georgia, in 1930, he studied at the University of South Carolina, Columbia. His work has been the subject of retrospectives at Columbia Museum of Art, South Carolina, 1960; Jewish Museum, New York City, 1964; The Whitechapel Art Gallery, London, England, 1964; Pasadena Art Museum, California, 1965; and he has shown at Leo Castelli Gallery, New York City, since 1958. The Whitney Museum of American Art, New York City, mounted a retrospective of his work in 1977. He lives and works in Stony Point, New York.

Jasper Johns' work utilizes an intellectual combination of abstract and representational conventions, often incorporating real or sculpted objects with expressionist surfaces. He works in sculpture, drawing, collage, painting and printing and consistently reinvents and reinterprets common symbols such as flags, targets and maps and objects such as a lightbulb, beer can, or flashlight. In occasional still-life sculptures, objects are cast in metal, set on a base and sometimes painted illusionistically.

ALEX KATZ

Born in Brooklyn, New York, in 1927, he studied at Cooper Union, New York City, 1946–49 and Skowhegan School of Painting and Sculpture, Maine, 1949–50. Since his first solo exhibitions at Roko Gallery, New York City, in 1954 and 1957, his work has been shown at Fischbach Gallery, New York City, 1964–71; Marlborough Gallery, New York City, since 1973; Whitney Museum of American Art, New York City, 1974; Robert Miller Gallery, New York City, since 1979; and The Queens Museum, Flushing, New York, 1980. The Utah Museum of Fine Arts, University of Utah, Salt Lake City, mounted a retrospective of his work in 1971. He lives and works in New York City.

Alex Katz began his career by painting from nature in an abstract manner but turned to a more realistic style in the mid-1950s painting still lifes, portraits and landscapes. The still lifes of the 1950s are of very ordinary domestic objects and are brighter in color and more spontaneous in line and brushwork than his later more formal, schematized portraits and landscapes.

YASUO KUNIYOSHI

Born in Okayama, Japan, in 1893, he moved to the United States in 1906. He studied at Los Angeles School of Art and Design, California, 1907–10 and at the National Academy, the Henri School, the Independent School of Art and the Art Students League, all in New York City, 1910–16. He had solo shows at Daniel Gallery, New York City, in 1922–30; Downtown Gallery, New York City, 1933–65; Portland Art Museum, Oregon, 1949; National Museum of Modern Art, Tokyo, Japan, 1954; and a retrospective at the Whitney Museum of American Art, New York City, 1947. The University Gallery, University of Florida, Gainesville, and the National Collection of Fine Arts, Washington, D.C., co-sponsored a retrospective of his work in 1969. He died in New York City in 1953.

Yasuo Kuniyoshi painted in a deliberately naive, blocky style until the late 1920s. Later, his images became more elusive, and his still-life and figure pictures are rendered with a concern for draftsmanship and graphic composition and use a somewhat surreal, undefined space. Kuniyoshi's still lifes often inspire reverie or despair. He combined his personal vision with the American concern for social realism and commentary prevalent during the 1920s and 1930s.

GABRIEL LADERMAN

Born in Brooklyn, New York, in 1929, he studied a Hans Hofmann School of Fine Arts, New York Cit 1949; Brooklyn College, New York, receiving his F in 1952; and Cornell University, Ithaca, New York receiving his M.F.A. in 1957. His first solo show at Cornell University, Ithaca, New York, in 1957, wa followed by exhibitions at Pratt Institute, Brookly New York, 1961, 1966; Robert Schoelkopf Gallery, York City, since 1964; University of Rhode Island, Kingston, 1970; Tyler School of Art, Temple Unive sity, Philadelphia, Pennsylvania, 1971–72; and th Institute of International Education, United Natic New York City, 1978. He lives and works in New York City.

Gabriel Laderman is best known for his still lifes, though he also paints landscapes and nudes. He di dains beautiful subjects or ones which imply pleas in favor of spartan objects in plain environments. Through light and shadow he conveys the volume three-dimensional objects and the relationship of metric forms in space. Dramatic light emphasizes solidity and simplicity of crockery and glassware i the still lifes. Laderman's direct frontal approach t the subject emphasizes the dignity of simple shape and severe surroundings.

JOHN LEES

Born in Denville, New Jersey, in 1943, he received B.F.A. and M.F.A. from Otis Art Institute, Los Angeles, California in 1967. He has had solo exhibiti at San Bernardino Valley College, California, 196 Edward Thorp Gallery, Santa Barbara, California New York City, since 1975; Braunstein Gallery, Sa Francisco, California, 1981; and Feigenson Gallery Detroit, Michigan, 1982. He lives and works in Ne York City.

John Lees has painted still-life subjects since 1972 paints canvases covered with many layers of paint From the depths of these encrusted canvases, the s ject emerges. He makes paintings of fish as well a the commonplace objects that surround him daily his home and studio such as paint brushes, coffee p and vases. His method of applying the paint and t resulting surfaces make the image elusive, poised tween abstraction and representation.

ALFRED LESLIE

Born in Bronx, New York, in 1927, he attended New York University and the Art Students League, both in New York City, 1946–49. Since his first show at Kootz Gallery, New York City, in 1949, his work has been exhibited at Tibor de Nagy Gallery, New York City, 1951, 1952, 1953, 1957, and Allan Frumkin Gallery, New York City and Chicago, since 1975. The Museum of Fine Arts, Boston, Massachustts, mounted a retrospective of his work in 1976. He lives and works in South Amherst, Massachusetts.

Alfred Leslie primarily paints portraits and historical events. His portraits and few still lifes, while necessarily more intimate than the historical paintings, are equally dramatic and monumental. The still lifes are not as directly narrative as his other works but do contain that element and make use of the same monumental qualities and harsh, focused light as the rest of his oeuvre. He feels his work can serve as a moral force and can influence the conduct of people.

ROY LICHTENSTEIN

Born in New York City in 1923, he attended the Art Students League, New York City, 1939; and Ohio State University, Columbus, 1940–43, and 1949 when he received his M.F.A. His first solo exhibitions at John Heller Gallery, New York City, 1952, 1953, 1954, 1957; were followed by exhibitions at Leo Castelli Gallery, New York City, since 1962; The Solomon R. Guggenheim Museum, New York City, 1969; The Mayor Gallery, London, England, since 1974; Centre National d'Art Contemporain, Paris, France, 1975; Nationalgalerie, Berlin, West Germany, 1975; Mannheimer Kunstverein, Mannheim, West Germany, 1977; and the Institute of Contemporary Art, Boston, Massachusetts, 1978. The Saint Louis Art Museum, Missouri, organized a retrospective of ten years of his work in 1981. He lives and works in Southampton, New York.

Roy Lichtenstein is well known for his Pop paintings whose images he derives from comic book and other commercial sources. Between 1972 and 1974, he concentrated on a series of thirty-six still lifes of studio objects, fruit, glassware and plants. He chose these objects, as he did his previous images, for their familiarity. Like his other works, the still lifes are painted flatly, unemotionally and schematically. He deliberately refers visually to the still-life tradition, for example, by the incorporation of images which reinterpret still-life paintings by Harnett and Matisse.

LOUISA MATTHIASDOTTIR

Born in Reykjavik, Iceland, in 1917, she came to the United States in 1941. She has had solo shows at the Jane Street Gallery, New York City, 1948; Tanager Gallery, New York City, 1958; University of Connecticut, Storrs, 1967; Albrecht Gallery of Art, St. Joseph, Missouri, 1970; Framehouse Gallery, Louisville, Kentucky, 1971; Windham College, Putney, Vermont, 1972; Litchfield Art Center, Connecticut, 1972; University of New Hampshire, Durham, 1978; and Robert Schoelkopf Gallery, New York City, since 1964. She lives and works in New York City.

Louisa Matthiasdottir uses traditional elements of still life such as mirrors, glassware, knives, fruits or vegetables set on tables draped with a piece of material. Each object is painted in a flat and abstract manner. She emphasizes the reflective skin of a tomato or eggplant or the translucence of a bottle of honey or a jug of wine. It is her use of strong color and broad, forthright brushstrokes that make these works distinct.

NANCY MITCHNICK

Born in Detroit, Michigan, in 1947, she attended Wayne State University, Detroit, Michigan, where she received her B.F.A. in 1972. She has had solo exhibitions at Willis Gallery, Detroit, Michigan, 1973; Susanne Hilberry Gallery, Birmingham, Michigan, 1980, 1982; and Hirschl & Adler Modern, New York City, 1983. She lives and works in New York City.

Nancy Mitchnick paints still lifes, portraits and landscapes. Her approach to her chosen subject is frontal and direct, her use of paint thick, her lines sinuous and her colors vibrant. In the still lifes she isolates plants, flowers and vases set on pedestals in a field of solid color. She paints to the very edge of the canvas; images are sometimes even truncated as if the scene continues beyond the frame.

MALCOLM MORLEY

Born in London, England, in 1931, he attended the Royal College of Art, London, England, 1954–57. He moved to the United States and received an M.F.A. from Yale University, New Haven, Connecticut, in 1957. He has had solo shows at Kornblee Gallery, New York City, 1957–69; Institute of Art and Urban Resources, The Clocktower, New York City, 1976; Wadsworth Atheneum, Hartford, Connecticut, 1980; Xavier Fourcade, Inc., New York City, since 1980; and Akron Art Museum, Ohio, 1981. The Whitechapel Art Gallery, London, England, organized a retrospective of his work in 1983. He lives and works in New York City and Tampa, Florida.

Malcolm Morley, one of England's first generation Pop painters, began to paint images gleaned from the media in the mid-1960s. His work has always confronted the illusionistic propositions of making three dimensions into two, and his rare still-life subjects share this imagery and concern. His technical brilliance and proficiency allow him to demonstrate the various ways paint can be used and his still lifes are closely related in style to his current painterly, expressionist works.

WALTER MURCH

Born in Toronto, Canada, in 1907, he attended the Ontario College of Art, Toronto, Canada, 1925–27, and the Art Students League, New York City, 1927. His first solo exhibition at Christodora House, New York City, in 1929, was followed by exhibitions at Wakefield Gallery, New York City, 1941, and Betty Parsons Gallery, New York City, since 1947. The Rhode Island School of Design, Providence, mounted a retrospective of his work in 1966. He died in New York City in 1967.

Walter Murch developed a distinct style that was uniquely his own and was only peripherally influenced by his friend Cornell, his teacher Gorky, and his many years as a professional illustrator. His luminous paintings are still-life studies of three-dimensional geometric objects, machinery, and household dry g as well as a few carefully selected natural objects dered within a narrow and often monochromatic t range. His canvases are imbued with stillness and luminated by the glowing reflection of light off sol objects set against an undifferentiated ground.

CATHERINE MURPHY

Born in Cambridge, Massachusetts, in 1946, she a tended the Skowhegan School of Painting and Scu ture, Maine, 1966, and received her B.F.A. from Pr Institute, Brooklyn, New York, in 1967. She had he first solo exhibition at First Street Gallery, New Yo City, in 1971, followed by solo exhibitions at Fourc Droll, Inc., New York City, 1975; The Phillips Colle tion, Washington, D.C., 1976; Institute of Contemp rary Art, Boston, Massachusetts, 1976; and Xavier Fourcade, Inc., New York City, since 1979. She live and works in Poughkeepsie, New York.

Catherine Murphy paints traditional landscapes, p traits and interiors with still life, all of which are characterized by an objective vision and meticulou detailed surfaces. Her dispassionate eye equalizes t jars and bottles or envelopes and letters found in h still lifes with large buildings or trees in the land- scapes. Her technique, subject matter, composition use of deep perspectival space exist totally within t academic tradition. However, the overall density, e emphasis on each component and fidelity to the tw dimensionality of the canvas firmly place her work the twentieth century.

ALICE NEEL

Born in Merion Square, Pennsylvania, in 1900, she attended Philadelphia School of Design for Women, Pennsylvania, 1921–25. Since her first solo exhibition in Havana, Cuba, in 1926, her work has been exhibited at Graham Gallery, New York City, 1963–80 and Robert Miller Gallery, New York City, since 1982; and in retrospectives at the Whitney Museum of American Art, New York City, 1974; Georgia Museum of Art, University of Georgia, Athens, 1975; University of Bridgeport, Connecticut, 1979; and Loyola Marymount University, Los Angeles, California, 1983. She lives and works in New York City.

Alice Neel is best known for the portraits she paints of friends and family. The still lifes that comprise the other part of her oeuvre often have the same foreshortening and flowing line common to the portraits. Neel's approach to her subject is direct and frontal; there is an isolation of object and figure alike. She paints heavily in some areas of the canvas and leaves others virtually untouched. In the still-life paintings, the chairs and tables on which fruit, flowers, fish and glassware sit are thrust forward, extending the picture plane into the viewer's space. This confrontation with the subject is also found in her powerful portraits.

JUD NELSON

Born in New York City in 1943, his work has been in solo exhibitions at Bykert Gallery, New York City, 1973, 1976; Max Protetch Gallery, New York City, 1977; Protetch McIntosh, Washington, D.C., 1977; Robert Miller Gallery, New York City, 1978, 1979; University Gallery, Fine Arts Center, University of Massachusetts, Amherst, 1980; Walker Art Center, Minneapolis, Minnesota, 1981; Louis K. Meisel Gallery, New York City, 1983; and the Gerald R. Ford Museum, Grand Rapids, Michigan, 1983. He lives and works in New York City.

Jud Nelson skillfully cuts mundane objects—folding chairs, teabags, bread slices or toilet paper rolls— from Styrofoam and more recently from white Carrara marble. Usually working serially, Nelson makes each object unique and life-size. Alone or seen in sets these sculptures stand quietly as still lifes isolated from any context. Nelson is able to create illusions of verisimilitude of everyday objects in sculpture that recalls *trompe l'oeil* in painting.

CLAES OLDENBURG

Born in Stockholm, Sweden, in 1929, he came to the United States in 1936. He attended Yale University, New Haven, Connecticut, receiving his B.A. in 1951; Art Institute of Chicago, Illinois, 1952–54; and the Oxbow Summer School of Painting, Saugatuck, Michigan, 1953. He had solo exhibitions in 1956 at Cooper Union, New York City, and at Judson Gallery, New York City; Moderna Museet, Stockholm, Sweden, 1966; Museum of Contemporary Art, Chicago, Illinois, 1967; Stedelijk Museum, Amsterdam, the Netherlands, 1971; Pasadena Art Museum, California, 1971; and Walker Art Center, Minneapolis, Minnesota, 1975. The Museum of Modern Art, New York City, mounted a retrospective of his work in 1969. He lives and works in New York City.

Claes Oldenburg, one of the foremost Pop artists, came to public attention in the late 1950s. Both his small and monumental works derive their forms from food and common objects traditional to still life. He reduces his subjects to simple, yet still identifiable forms, and often greatly enlarges their size. His works in various media are taken from objects which surround him daily and reflect his inventive wit as well as a sense of inherent contradiction in form, function and material. His transformation of common objects through his use of non-traditional sculptural materials and monumental scale forces the viewer to abandon preconceived notions of reality.

RICHARD PICCOLO

Born in Hartford, Connecticut, in 1943, he studied at
Pratt Institute, Brooklyn, New York; Art Students
League, New York City; and Brooklyn College, New
York. He has had solo exhibitions at Robert Schoelkopf
Gallery, New York City, 1975, 1977, 1983; American
Academy in Rome, Italy, 1977; and the Galleria
Temple, Rome, Italy, 1979. He lives and works in
Rome, Italy.

Richard Piccolo's paintings are rooted in Roman classi-
cism. He incorporates the myths and allegories of that
era, the monumental proportions and forms of its
sculpture and architecture, as well as the Italian land-
scape into his art. In the still lifes, large beribboned
fruits and vegetables fill the foreground of the canvas
while landscapes stretch across the background. The
food is monumental and the stalk of an artichoke for
example takes on the dimensions and characteristics
of a temple column.

FAIRFIELD PORTER

Born in 1907 in Hubbard Woods, Winnetka, Illinois,
he attended Harvard College, Cambridge, Mas-
sachusetts, where he received a B.S. in Fine Arts in
1928, and the Art Students League, New York City,
1928–30. His work has been exhibited at North Shore
Art Center, Winnetka, Illinois, in 1939; Rhode Island
School of Design, Providence, 1959; Cleveland Mu-
seum of Art, Ohio, 1966; Gross McCleaf Gallery, Phila-
delphia, Pennsylvania, 1969, 1978, 1979; Parrish Art
Museum, Southampton, New York, 1971, 1977; and
Hirschl & Adler Galleries, New York City, since 1972.
The Museum of Fine Arts, Boston, Massachusetts,
mounted a retrospective of his work in 1982. He died
in Southampton, New York in 1975.

Fairfield Porter's paintings are of subjects he knew
well. Although always a representational painter, he
understood, and his work was influenced by, Abstract
Expressionism. Porter's still lifes, landscapes, interiors
and portraits are suffused with warm, welcoming and
familiar light. His work is characterized by its use of
strong compositional elements and color used to define
form. His still lifes are similar in feeling and content
to his landscapes and interiors; they are remarkable
in their use of modernist methods to make traditional
statements.

LARRY RIVERS

Born in Bronx, New York, in 1923, he studied at N
York University, New York City, 1948–51, receivin
his B.A. in 1951. Since his first solo exhibition at t
Jane Street Gallery, New York City, in 1949, his wc
has been seen in retrospectives at The New School
Center, New School for Social Research, New York
City, 1963; Rose Art Museum, Brandeis University
Waltham, Massachusetts, 1965; Museo de Arte Co
temporaneo de Caracas, Venezuela, 1980; Kestner-
Gesellschaft, Hanover, West Germany, 1980; and th
Hirshhorn Museum and Sculpture Garden, Smith-
sonian Institution, Washington, D.C., 1981. His wc
has been shown at Tibor de Nagy Gallery, New Yor
City, 1951–61; and Marlborough Gallery, New Yor
City and London, England, since 1970. He lives an
works in New York City and Southampton, New Y

Larry Rivers' paintings in an Abstract Expression
style are of familiar people, places and things. For
past few years, he has increasingly included in his
work figures and references to artists and the art
world, past and present. His works in still life are
sculptures which are three-dimensional realization
his themes on canvas. They are constructed of woo
and painted representationally. Rivers continuousl
refines and reworks his themes, exploring them in
creasing range and depth and giving his whole wor
sense of sequence.

HARRY ROSEMAN

Born in Brooklyn, New York, in 1945, he received
B.F.A. from Pratt Institute, Brooklyn, New York, i
1967. He has had solo exhibitions at Piper Gallery,
Lexington, Massachusetts, 1969; Davis & Long
Company, New York City, 1979; Daniel Weinberg G
lery, Los Angeles/San Francisco, California, since
1982; and the University Art Museum, University
California, Santa Barbara, 1983. He lives and wor
in Poughkeepsie, New York.

Harry Roseman has made, for the past fifteen year
bronze and aluminum reliefs depicting cityscapes,
landscapes, and interiors with still life. The still lif
are small, monochromatic tableaux of object-laden
shelves or tabletops with domestic objects such as
lamp and a television. These low reliefs are decepti
for in a small, shallow space, Roseman produces w
with a larger sense of scale and depth than the act
width of the material would seem to allow. In the r
painted works, this illusion becomes true *trompe l'*

LUCAS SAMARAS

Born in 1936 in Macedonia, Greece, he came to the United States in 1948. He received a B.A. from Rutgers University, New Brunswick, New Jersey, in 1959 and an M.F.A. in art history from Columbia University, New York City, in 1962. Solo exhibitions of his work have been presented at Museum of Contemporary Art, Chicago, Illinois, 1971; Whitney Museum of American Art, New York City, 1972; The Museum of Modern Art, New York City, 1975; Walker Art Center, Minneapolis, Minnesota, 1977; Galerie Watari, Tokyo, Japan, 1981; and Denver Art Museum, Colorado, 1982. His work has been shown at The Pace Gallery, New York City, since 1966. He lives and works in New York City.

Lucas Samaras works in series, surrealistically transforming conventional objects like books, place settings, chairs and boxes. He has made two types of still-life works: lush pastels of traditional tabletops with vases of flowers and sculptures of place settings composed of mangled silverware, with meals of glass shards, pins and razor blades. These assemblage works are at once seductive and repellant. Samaras' emphasis on color, pattern and texture tie together his large and varied body of work.

GEORGE SEGAL

Born in 1924 in New York City, he received a B.A. from New York University, New York City, in 1950 and an M.F.A. from Rutgers University, New Brunswick, New Jersey, in 1963. His work has been in solo exhibitions at Sidney Janis Gallery, New York City, since 1965; Onnasch Galerie, Cologne, West Germany, 1971; Institute of Contemporary Art, University of Pennsylvania, Philadelphia, 1976; The Art Museum and Galleries, California State University, Long Beach, 1977; Seibu Museum of Art, Tokyo, Japan, 1982; and

Israel Museum, Jerusalem, 1983. The Walker Art Center, Minneapolis, Minnesota, organized a retrospective of his work in 1978. He lives and works in South Brunswick, New Jersey.

George Segal turned from abstract painting to sculpture in the late 1950s and began the plaster figures for which he is best known in 1960. These sculptures are cast from live models so that while the true image of the model is captured on the inside, it is invisible, yet referred to, by the outer shell. In a series of still-life sculptures Segal uses the same kind of tableau format as with the figurative works. The elevation of ordinary things to a spiritual status is particularly evident in the works in which he pays homage to the still-life master, Cézanne. There is a quiet timelessness about the frozen scenes in which objects retain their own inviolate presence.

RICHARD SHAW

Born in Hollywood, California, in 1941, he received his B.F.A. from San Francisco Art Institute, California, in 1965 and his M.F.A. from the University of California, Davis, in 1968. Since his first solo exhibition at San Francisco Art Institute, California, in 1967, his work has been seen at Quay Gallery, San Francisco, California, 1970, 1971, 1973; Braunstein/Quay Gallery, New York City and San Francisco, California, 1976; Braunstein Gallery, San Francisco, California, since 1979; and Allan Frumkin Gallery, New York City, since 1980. The Newport Harbor Art Museum, Newport Beach, California, organized a retrospective of his work in 1981. He has taught at San Francisco Art Institute, California, since 1965. He lives and works in Fairfax, California.

Richard Shaw is a sculptor in ceramics, working within the visual tradition of *trompe l'oeil*. His technical virtuosity and novel approach to his medium are a result of his appreciation of both English and Chinese ceramic traditions. The still lifes are life-size sculptures composed of stacks of objects: books, letters, cups, cigarettes and even a house of cards, all made of painted clay. He also makes humorous figures that look as if they are composed of cans, spools of string, sticks, paintbrushes and rubber tubing, but here too the eye is deceived for they are made entirely of clay.

CHARLES SHEELER

Born in Philadelphia, Pennsylvania, in 1883, he attended the School of Industrial Art, Philadelphia, Pennsylvania, 1900–03 and the Pennsylvania Academy of Fine Arts, Philadelphia, 1903–06. Since his first solo show at McClees Gallery, Philadelphia, Pennsylvania, in 1906, his work has been shown in exhibitions at the Daniel Gallery, New York City, 1922; Whitney Studio, New York City, 1924; Downtown Gallery, New York City, 1931–66; Walker Art Center, Minneapolis, Minnesota, 1952; Whitney Museum of American Art, New York City, 1980; and in retrospective exhibitions at The Museum of Modern Art, New York City, 1939; Art Galleries, University of California, Los Angeles, 1954; Allentown Art Museum, Pennsylvania, 1961; and the University of Iowa, Iowa City, 1963. He died in 1965 in Dobbs Ferry, New York.

Charles Sheeler took America as his subject matter. Maintaining a thriving photographic career into the 1930s, he used the Ford Motor Company plant at River Rouge, Michigan; Bucks County, Pennsylvania, farmhouses; and Shaker architecture and decorative arts as subjects in his works. The potted plants and fruit in his early still lifes were superseded by paintings in which his personal collection of American pottery took precedence. Sheeler's paintings are marked by sharp clear light and his crystalline delineation of form, which in concert enhance the abstract pattern of the painted surface.

DAVID SMITH

Born in Decatur, Indiana, in 1906, he attended Ohio University, Athens, 1924; Notre Dame University, South Bend, Indiana, 1925; and Art Students League, New York City, 1926–31. He had solo exhibitions at East River Gallery, New York City, 1938; Willard Gallery, New York City, 1940–56; Fogg Art Museum, Harvard University, Cambridge, Massachusetts, 1966; Tate Gallery, London, England, 1966; The Solomon R. Guggenheim Museum, New York City, 1969; and the Hirshhorn Museum and Sculpture Garden, Smithsonian Institution, Washington, D.C., 1979 and 1982.

A retrospective of his work was organized by The National Gallery of Art, Washington, D.C., in 1982. His work has been shown by M. Knoedler & Co., Inc., New York City, since 1976. He died near Bennington, Vermont in 1965.

David Smith's sculptures made over a twenty-year period reflected many of the major artistic movements of the twentieth century and in turn influenced many sculptors and painters. Smith made sculpture reminiscent of landscapes and figures. The best known of his sculptures are large outdoor pieces created of welded steel. He made only a few still-life sculptures, three of which are part of the *Voltri* series—a set of twenty-five works he made in a month in Voltri, Italy. He constructed these still lifes out of steel from abandoned factories, welded together with found objects.

NILES SPENCER

Born in Pawtucket, Rhode Island, in 1893, he studied Rhode Island School of Design, Providence, 1913–15. His work was exhibited at the Whitney Studio Club, New York City, 1923–30; and in solo exhibitions at Daniel Gallery, New York City, 1925, 1928; and the Downtown Gallery, New York City, 1947, 1952. Retrospectives of his work were mounted by The Museum of Modern Art, New York City, 1954 and University Kentucky Art Gallery, Lexington, 1965. He died in 1952 in Dingham's Ferry, Pennsylvania.

Niles Spencer was primarily a painter of urban landscapes. He took the detached stance of an observer, distilling natural and manmade forms to the purest expression of structure and design. His paintings displayed the common enthusiasm for modernism, industry and progress of the period between the two world wars. The schematized, geometric format of these paintings is made more intensely abstract by his use of color. Figures are rarely present in his paintings, and the still lifes contain the few personal references to be found in his work.

SAUL STEINBERG

Born in Ramnicul-Sarat, Bucharest, Rumania, in 1914, he was educated in Rumania and Italy in philosophy and letters, and architecture. He came to the United States in 1942 and had his first solo exhibition in 1943 at Wakefield Gallery, New York City. His work has been exhibited in retrospectives at the National Collection of Fine Arts, Smithsonian Institution, Washington, D.C., 1973; Kolnischer Kunstverein, Cologne, West Germany, 1974; Whitney Museum of American Art, New York City, 1978; and The Pace Gallery, New York City, 1982. He lives and works in Amagansett, New York.

Saul Steinberg is best known for his drawings and watercolors which are focused on many subjects from world politics to the debris of daily life. His still lifes often incorporate collaged materials and concentrate on the artist's tools and the images they can create. All of his work has a sophisticated and circular humor.

BILLY SULLIVAN

Born in New York City in 1946, he attended the High School of Art and Design, New York City, 1964, and the School of Visual Arts, New York City, 1968. His first solo show at Contract Graphics, Houston, Texas, in 1971, was followed by exhibitions at Duffy & Sons, New York City, 1974; Sarah Y. Rentschler Gallery, New York City, 1978; and Kornblee Gallery, New York City, since 1978. He lives and works in New York City.

Billy Sullivan's use of bright color and flowing line defines intimate scenes of people in conversation as well as still lifes of flowers and food. Although he works from photographs taken to record a particular moment, his paintings contain none of the static, documentary quality of a photograph. Apparently found, and not arranged, his impressionistically rendered still lifes have the informal air of a meal caught in progress or pot of flowers casually left on a table.

JIM SULLIVAN

Born in Providence, Rhode Island, in 1939, he received his B.F.A. from Rhode Island School of Design, Providence, in 1961. Since his first solo shows at Paley & Lowe, Inc., New York City, in 1971, 1973; his work has been in solo shows at Henri Gallery, Washington, D.C., 1974; Fischbach Gallery, New York City, 1974; Willard Gallery, New York City, 1978; Nancy Hoffman Gallery,

New York City, since 1980; Folker Skulima Gallery, Berlin, West Germany, 1982; and Galerie Wolfgang Werner, Bremen, West Germany, 1983. He has taught at Bard College, Annandale-on-Hudson, New York, since 1965. He lives and works in New York City.

Jim Sullivan's recent paintings are composed of two layers of images. He uses two types of brushstroke, a combination of color and grisaille and a variety of media to further distinguish the bipartite nature of these works. In the pictures which incorporate still life, he superimposes a traditional still-life subject, such as a bowl filled with apples, over a collage of other images. Sullivan's works are characterized by traditional painterly illusion heightened by contradictory imagery and by the use of collage.

WAYNE THIEBAUD

Born in Mesa, Arizona, in 1920, he received his B.A. and M.A. from Sacramento State College, California, in 1951 and 1952 respectively. Since his first solo show at Crocker Art Museum, Sacramento, California, in 1950, he has had exhibitions at Allan Stone Gallery, New York City, since 1964; T. W. Stanford Art Gallery and Museum of Art, Stanford University, Palo Alto, California, 1965; Pasadena Art Museum, California, 1968; Crocker Art Museum, Sacramento, California, 1970; The Art Museum and Galleries, California State University, Long Beach, 1972; and Walker Art Center, Minneapolis, Minnesota, 1981. The Phoenix Art Museum, Arizona, mounted a retrospective of his work in 1976. He has taught since 1960 at the University of California, Davis. He lives and works in Sacramento, California.

Wayne Thiebaud's best-known images are ones of food painted in a stylized manner with thick impasto. In these still lifes, the image may be repeated several times in a single canvas. Sometimes the objects are depicted in undefined space and sometimes presented in a context like a cafeteria, bakery window or on a plate. His imagery has often caused him to be related to the Pop artists, but he developed his way of working and his images independently of most of the artists associated with that movement. The texture of the heavy paint and his individualistic use of color produce an agitated surface which is in direct contrast to the stillness of the objects..

SIDNEY TILLIM

Born in Brooklyn, New York, in 1925, he received his
B.F.A. from Syracuse University, New York, in 1950.
Solo shows of his work have been held at Robert
Schoelkopf Gallery, New York City, 1965, 1967; Noah
Goldowsky Gallery, New York City, 1969, 1974; Ed-
monton Art Gallery, Alberta, Canada, 1973, 1976;
Tibor de Nagy Gallery, New York City, 1977; and Mer-
edith Long Contemporary, New York City, 1979. He
has taught at Bennington College, Vermont, since
1966. He has been a contributing editor for *Arts Mag-
azine*, 1959–65 and *Artforum*, 1965–69. He lives and
works in New York City.

Sidney Tillim's paintings have varied in style and sub-
ject matter throughout his career: Cubist abstractions
of the 1950s preceded the still lifes of the 1960s which
in turn, developed into figurative and historical, nar-
rative paintings during the 1970s. The immobile,
static nature of his still lifes are grounds for tight
surface organization as well as symbolic metaphors for
action. He deliberately chooses banal subject matter in
order to explore and demonstrate how the design of a
painting can endow it with a function above its actual
use. Tillim recently returned to abstraction because he
felt the demands he placed on the representational
works were becoming obstacles to the actual process of
painting.

JAMES VALERIO

Born in Chicago, Illinois, in 1938, he received his
B.F.A. and M.F.A. from the Art Institute of Chicago,
Illinois, in 1966 and 1968 respectively. Since his first
solo shows at Gerald Johns Hayes Gallery, Los An-
geles, California, in 1971, 1972; his work has been
shown in exhibitions at the Tucson Art Center, Ari-
zona, 1973; Michael Walls Gallery, New York City,
1974; John Berggruen Gallery, San Francisco, Califor-
nia, 1977; and Frumkin & Struve Gallery, Chicago,
Illinois, since 1981. He lives and works in Ithaca, New
York.

James Valerio's still-life subjects consist of draped
tabletops loaded with fruit, glassware, flowers, plants
and occasionally food. His use of local color and un-
compromising attention to minute detail produce
paintings which represent a contemporary version of

traditional tabletop still lifes. In these works, the
jects become seemingly real, as no aspect of their
ence is emphasized over another and none escapes
artist's eye or brush. Like his figurative compositi
his still lifes are monumental in scale, and this li
them to contemporary concerns.

ANDY WARHOL

Born in Pittsburgh, Pennsylvania, in 1930, he re-
ceived his B.F.A. from Carnegie Institute of Techn
ogy, Pittsburgh, Pennsylvania, in 1949. Since his f
show at Hugo Gallery, New York City, in 1952, ret-
rospectives of his work have been organized by the
Moderna Museet, Stockholm, Sweden, 1968; Pasad
Art Museum, California, 1970; Württembergische
Kunstverein, Stuttgart, West Germany, 1976; Whi
Museum of American Art, New York City, 1979;
Portland Center for the Visual Arts, Oregon, 1980;
Kestner-Gesellshaft, Hanover, West Germany, 198
and shows of his work have been held at Leo Caste
Gallery, New York City, since 1964. He lives and
works in New York City.

Andy Warhol is perhaps the best-known artist to
emerge from the 1960s, and his oeuvre now encom
passes film, photography, and writing as well as pa
ing, sculpture, drawing and graphics. His use of co
mercial images and techniques has rendered his
works ubiquitous. Warhol has consistently focused
removing objects from their usual surroundings ar
contexts, simplifying their forms, and heightening
their essential, most communicative characteristic
through mechanical means of reproduction. This i
tion of objects places many of his works within the
still-life tradition of contemporary American paint

TOM WESSELMANN

Born in Cincinnati, Ohio, in 1931, he received a B.
from the University of Cincinnati, Ohio, in 1956. F
had his first solo exhibition in 1961 at Tanager Ga
lery, New York City, and his work has been shown
Sidney Janis Gallery, New York City, since 1966. E
hibitions of his work have been mounted at Newpo
Harbor Art Museum, Newport Beach, California,

1970; The Art Galleries and Museum, California State University, Long Beach, 1974; Institute for Contemporary Art, Boston, Massachusetts, 1978; and Delahunty Gallery, Dallas, Texas, 1983. He lives and works in New York City.

Tom Wesselmann's extensive series of nudes started in the late 1950s and often included still lifes. His later true still lifes are composed of domestic interiors, usually with a collage of household objects affixed. Begun in the late 1970s, a series of huge still-life relief paintings and three-dimensional sculptures are based on shoes, flowers, jewelry, food and cigarettes—everyday objects. He uses metamorphosis to take the mundane object to monumental, almost abstract, form.

PAUL WIESENFELD

Born in Los Angeles, California, in 1942, he received his B.F.A. from Chouinard Art Institute, Los Angeles, California, in 1959 and his M.F.A. from Indiana University, Bloomington, in 1968. Since his first solo exhibition at the Indiana University Art Gallery, Bloomington, in 1968, he has had shows at Galerie Hartman, Munich, West Germany, 1969; Robert Schoelkopf Gallery, New York City, 1973, 1976, 1981; Neue Gallery, Aachen, West Germany, 1976; and the Stadtische Gallerie Im Lenbachhaus, Munich, West Germany, 1980. He lives and works in Landshut, West Germany.

Paul Wiesenfeld paints figures, interiors and still lifes that are characterized by their clear appearance. In his interior still lifes, objects are arranged on a tabletop with great precision. The forms are painted in such a way as to define and emphasize both the flat surfaces and the rounded forms. He employs materials and techniques skillfully to produce a picture surface which enhances the purity of forms.

DONALD ROLLER WILSON

Born in Houston, Texas, in 1938, he received his B.F.A. from Wichita State University, Kansas, in 1964 and his M.F.A. from Kansas State University, Manhattan, in 1966. Since the first solo shows of his work at the Wichita Art Museum, Kansas, and Wichita State University, Kansas, in 1966, his work has been exhibited at the Contemporary Arts Museum, Houston, Texas, 1969; French and Co. Galleries, New York City,

1972; La Jolla Museum of Contemporary Art, California, 1974; Moody Gallery, Houston, Texas, since 1977; John Berggruen Gallery, San Francisco, California, 1978; University Fine Arts Gallery, Florida State University, Tallahassee, 1979; and Fendrick Gallery, Washington, D.C., 1982. A retrospective of his work was shown at the William Rockhill Nelson Gallery of Art, Atkins Museum of Fine Art, Kansas City, Missouri, in 1970. He lives and works in Fayetteville, Arkansas.

Donald Roller Wilson's haunting, sometimes humorous, paintings are surreal in intent. In 1980, tabletop still lifes begin to take precedence in his work. These paintings focus on complex arrangements of meal remnants as well as on objects flying and floating through the air. Although people are not present, there are traces of human habitation such as halfeaten food and half-smoked cigarettes. The works have a smooth, highly finished surface and are typified by the conjunction of the probable and improbable and the static and mobile.

JANE WILSON

Born in Seymour, Iowa, in 1924, she received her B.A. and M.A. from the University of Iowa, Iowa City, in 1945 and 1947 respectively. Since her first solo shows at Hansa Gallery, New York City, 1953, 1955, 1957; her work has been exhibited at Graham Gallery, New York City, 1968–75; Westark Community College, Fort Smith, Arkansas, 1976; Fischbach Gallery, New York City, since 1978; Munson-Williams-Proctor Institute, Utica, New York, 1980; and The Art Gallery, Malott Hall, Cornell University, Ithaca, New York, 1982. She lives and works in New York City.

Jane Wilson's work is typified by a soft shimmering paint surface. Her interior still-life pictures are impressionistic in color and feeling. Tabletops and mantlepieces serve as the resting place for vessels, fruit and fish which are deliberately placed against layered and patterned drapery. The objects achieve focus by their placement within the highly structured composition. Even lighting and clearly defined spatial relationships unite disparate objects and intricate drapery.

PAUL WONNER

Born in Tucson, Arizona, in 1920, he received a B.A. from California College of Arts and Crafts, Oakland, in 1941 and a B.A. and M.A. from University of California, Berkeley, in 1952 and 1953 respectively. Since his first solo exhibition at the M. H. de Young Memorial Museum, San Francisco, California, in 1955, his work has been shown at the San Francisco Museum of Art, California, 1956; Felix Landau Gallery, Los Angeles, California, 1959–71; Marion Koogler McNay Art Institute, San Antonio, Texas, 1965, 1981; John Berggruen Gallery, San Francisco, California, since 1978; and James Corcoran Gallery, Los Angeles, California, 1979, 1980. The San Francisco Museum of Modern Art, California, mounted a retrospective of his work in 1981. He lives and works in San Francisco, California.

Paul Wonner painted abstractions through the 1950s, but by the mid-1960s his subjects were mostly still lifes. He approaches still life as if it were landscape, dividing the painting horizontally. This division leads the eye to objects isolated on the lower part of the canvas. Each of the depicted objects is physically independent of every other, and their placement creates a strong vertical perspective leading to a single vanishing point. Wonner pays homage to the long tradition of painting by including *trompe l'oeil* reproductions of works by the Old Masters.

ALBERT YORK

Born in Detroit, Michigan, in 1926, he studied at the Ontario College of Art, Toronto, Canada, and the Society of Arts and Crafts, Detroit, Michigan. His work has been exhibited in solo shows at Davis Galleries, New York City, 1963, 1964, 1966, 1969; Davis & Long Company, New York City, 1975, 1977, 1978; Davis & Langdale Company, Inc., New York City, 1982; and the Museum of Fine Arts, Boston, Massachusetts. He lives and works in New York State.

Albert York's still-life watercolors and paintings are small in scale and verge on the whimsical. His still lifes of flowers are often set in nature. Within these pastoral scenes, he places gentle reminders of man's encroachment. Flowers will be in a tin can, a fence will cut across a field or a horse and rider will appear in the distance. The very stillness of these works is subtly disturbed by a rippling sense of the constant cycle of life and death and of man's continuing conquest and development of the wilderness.

JOE ZUCKER

Born in Chicago, Illinois, in 1941, he attended the Institute of Chicago, Illinois, 1961–66, receiving h B.F.A. in 1964 and M.F.A. in 1966. He has had solo exhibitions at Heistand Hall Art Gallery, Miami U versity, Oxford, Ohio, 1965; Bykert Gallery, New Y City, 1974, 1975, 1976; Texas Gallery, Houston, Tex 1974, 1976, 1983; The Baltimore Museum of Art, M land, 1976; Holly Solomon Gallery, New York City, 1978–83; The Mayor Gallery, London, England, 19 1980, 1981; Galerie Bischofberger, Zürich, Switzerland, 1979; University Art Museum, University of California, Berkeley, 1981; and La Jolla Museum o Contemporary Art, California, 1982. The Albright Knox Art Gallery, Buffalo, New York, mounted a re rospective of his work in 1982. He lives and works New York City and East Hampton, New York.

Joe Zucker constructs images from cotton balls soa in acrylic paint and applied to the canvas. The stil life images of vessels he made by this deliberate a additive process are historically faithful to their m els. Zucker sets up a dichotomy between this repro tion, the physicality of the surface and a contempo emphasis on process.

*S*ELECTED READINGS

The following references pertain to historical and contemporary still life. The books and catalogues on individual artists are included because they make specific reference to the topic.

BOOKS

Baigell, Matthew. *Thomas Hart Benton.* New York: Harry N. Abrams, Inc., 1974.

Börn, Wolfgang. *Still-Life Painting in America.* New York: Hacker Art Books, 1973.

Coe, Ralph T. *The Dreams of Donald Roller Wilson.* New York: Hawthorn Books, Inc., 1979.

Frankenstein, Alfred V. *After the Hunt: William Harnett and Other American Still Life Painters, 1870–1900.* 2d ed., rev. Berkeley, Los Angeles and London: University of California Press, 1975.

Friedlaender, Walter, *Caravaggio Studies.* Princeton, New Jersey: Princeton University Press, 1955.

Gerdts, William H. and Burke, Russell. *American Still Life Painting.* New York: Praeger Publishers, 1971.

Johnson, Ellen H. *Claes Oldenburg.* Middlesex, England and Baltimore, Maryland: Penguin Books Ltd., 1971.

Meisel, Louis K. *Photo Realism.* New York: Harry N. Abrams, Inc., 1980.

Milman, Miriam. *The Illusions of Reality: Trompe-L'Oeil Painting.* New York: Rizzoli International Publications, Inc., 1983.

Nochlin, Linda. *Realism and Tradition in Art 1848–1900.* Englewood Cliffs, New Jersey: Prentice-Hall, Inc., 1966.

Novak, Barbara. *American Painting of the Nineteenth Century.* 2d ed. New York: Harper & Row, Publishers, Inc., 1979.

Sandler, Irving. *Alex Katz.* New York: Harry N. Abrams, Inc., 1979.

Stealingworth, Slim. *Tom Wesselmann.* New York: Abbeville Press, Inc., 1980.

Sterling, Charles. *Still Life Painting: From Antiquity to the Twentieth Century.* 2d ed., rev. New York: Harper & Row, Publishers, Inc., 1981.

Wilmerding, John. *American Art.* Middlesex, England and New York: Penguin Books Ltd., 1976.

CATALOGUES

City Art Museum of St. Louis, Missouri. *The Development of Flower Painting From the Seventeenth Century to the Present*, May 1937. Catalogue text by Meyric R. Rogers.

Wadsworth Atheneum, Hartford, Connecticut. *The Painters of Still Life*, January 25–February 15, 1938. Catalogue text by Arthur Everett Austin, Jr.

The Museum of Modern Art, New York City. *Stuart Davis*, Fall 1945. Catalogue text by James Johnson Sweeney.

California Palace of the Legion of Honor, San Francisco. *Illusionism and Trompe L'Oeil*, May 3–June 12, 1949. Catalogue texts by Alfred V. Frankenstein, Douglas MacAgy and Jermayne MacAgy.

Brooklyn Institute of Arts and Sciences, The Brooklyn Museum, New York. *John F. Peto*, April 11–May 21, 1950. Catalogue text by Alfred V. Frankenstein.

The American Federation of Arts, New York City. *Harnett and His School*, September 1953–June 1954. Catalogue text by Alfred V. Frankenstein.

Milwaukee Art Institute, Wisconsin. *Still-Life Painting since 1470*, September 1956. Catalogue text by E. H. Dwight.

Whitney Museum of American Art, New York City. *Hans Hofmann*, April 24–June 16, 1957. Catalogue text by Frederick S. Wight.

The Corcoran Gallery of Art, Washington, D.C. *American Still Life Paintings from the Paul Magriel Collection*, October 2–November 10, 1957. Essay by John I. H. Baur.

Milwaukee Art Center, Wisconsin. *Raphaelle Peale, 1774–1825: Still Lifes and Portraits*, January 15–February 15, 1959. Catalogue text by Charles Coleman Sellers.

University of St. Thomas, Houston, Texas. *The Age of the Thousand Flowers*, March 9–April 30, 1962. Catalogue text by Jermayne MacAgy.

The Solomon R. Guggenheim Museum, New York City. *Philip Guston*, May 2–July 1, 1962. Catalogue text by H. H. Arnason.

National Collection of Fine Arts, Smithsonian Institution, Washington, D.C. *Stuart Davis Memorial Exhibition 1894–1964*, May 28–July 5, 1965. Catalogue text by H. H. Arnason.

La Jolla Museum of Art, California. *The Reminiscent Object, Paintings by William Michael Harnett, John Frederick Peto and John Haberle*, July 11–September 19, 1965. Catalogue text by Alfred V. Frankenstein.

University of Kentucky Art Gallery, Lexington. *Niles Spencer*, October 10–November 6, 1965. Catalogue text by Richard B. Freeman.

Museum of Art, Rhode Island School of Design, Providence. *Recent Still Life*, February 23–April 4, 1966. Catalogue text by Daniel Robbins.

Museum of Art, Rhode Island School of Design, Providence. *Walter Murch: A Retrospective Exhibition*, November 9–December 4, 1966. Catalogue text by Daniel Robbins.

The American Federation of Arts, New York City. *A Century of American Still-Life Painting, 1813–1913*, 1966. Catalogue text by William H. Gerdts.

The Detroit Institute of Arts, Michigan. *The Peale Family, Three Generations of American Artists*, January 18–March 5, 1967. Catalogue texts by Charles Elam, Edward H. Dwight, E. Grosvenor Paine and Charles Coleman Sellers.

Pasadena Art Museum, California. *Wayne Thiebaud*, February 13–March 17, 1968. Catalogue text by John Coplans.

National Collection of Fine Arts, Washington, D.C. *Charles Sheeler*, October 10–November 24, 1968. Catalogue texts by Martin Friedman, Bartlett Hayes and Charles Millard.

National Gallery of Art, Washington, D.C. *The Reality of Appearance; The Trompe L'Oeil Tradition in American Painting*, March 21–May 3, 1970. Catalogue text by Alfred V. Frankenstein.

University of Southern California, Los Angeles. *Reality and Deception*, October 16–November 24, 1974. Catalogue text by Alfred V. Frankenstein.

The Phillips Collection, Washington, D.C. *Catheri Murphy*, February 14–March 28, 1976. Catalogue by Judith Hoos.

Louis K. Meisel Gallery, New York City. *Audrey F "The Gray Border Series,"* April 10–May 1, 1976. Catalogue text by Bruce Glaser.

Albright-Knox Art Gallery, Buffalo, New York. *Richard Diebenkorn: Paintings and Drawings, 1943–1976*, November 12, 1976–January 9, 1977. Catalogue texts by Robert T. Buck, Jr., Linda L. Cathcart, Gerald Nordland and Maurice Tuchman.

Joslyn Art Museum, Omaha, Nebraska. *The Chosen Object: European and American Still* April 23–June 5, 1977. Catalogue text by Ruth H. Cloudman.

ACA Galleries, New York City. *American Flower Painting, 1850–1950*, April 1–22, 1978. Catalogue text by Dennis R. Anderson.

La Jolla Museum of Contemporary Art, California *Manny Farber*, May 5–June 25, 1978. Catalogue t by Amy Goldin.

National Gallery of Art, Washington, D.C. *Art at N Century: The Subjects of the Artist*, June 1, 1978– January 14, 1979. Catalogue text by E. A. Carmear

Robert Schoelkopf Gallery, New York City. *William Bailey: Recent Paintings*, January 6–February 10, 1979. Catalogue text by Mark Strand.

The Cleveland Museum of Art, Ohio, in cooperatio with Indiana University Press, Bloomington. *Char 1699–1779*, June 6–August 12, 1979. Catalogue t by Pierre Rosenberg.

The Cleveland Museum of Art, Ohio, in cooperatio with Indiana University Press, Bloomington. *Char and the Still-Life Tradition in France.* June 6–Aug 12, 1979. Catalogue text by Gabriel Weisberg.

Newport Harbor Art Museum, Newport Beach, Ca ifornia. *Vija Celmins: A Survey Exhibition*, Decem 15, 1979–February 3, 1980. Catalogue text by Sus C. Larsen.

San Francisco Musuem of Modern Art, California, in association with George Braziller, Inc., New York City. *Philip Guston*, May 16–June 29, 1980. Catalogue texts by Ross Feld and Henry T. Hopkins. Statements by the artist.

Whitney Museum of American Art, New York City. *Stuart Davis*, August 20–October 12, 1980. Catalogue text by Patterson Sims.

Philbrook Art Center, Tulsa, Oklahoma. *Realism/ Photo-Realism*, October 5–November 23, 1980. Catalogue text by John Arthur.

Robert Miller Gallery, New York City. *Janet Fish*, November 22–December 31, 1980. Catalogue text by Barry Yourgrau.

San Antonio Museum of Art, San Antonio Museum Association, Texas. *Real, Really Real, Super Real: Directions in Contemporary American Realism*, March 1–April 26, 1981. Catalogue texts by Alvin Martin, Linda Nochlin and Philip Pearlstein.

The Saint Louis Art Museum, Missouri, in association with Hudson Hills Press, Inc., New York City. *Roy Lichtenstein 1970–1980*, May 8–June 28, 1981. Catalogue text by Jack Cowart.

Pennsylvania Academy of the Fine Arts, Philadelphia, in association with the New York Graphic Society, Boston, Massachusetts. *Contemporary American Realism since 1960*, September 18–December 13, 1981. Catalogue text by Frank H. Goodyear, Jr.

Philbrook Art Center, Tulsa, Oklahoma, with the University of Missouri Press, Columbia and London. *Painters of the Humble Truth: Masterpieces of American Still Life 1801–1939*, September 27–November 8, 1981. Catalogue text by William H. Gerdts.

Rutgers University Art Gallery, New Brunswick, New Jersey. *Realism and Realities: The Other Side of American Painting, 1940–1960*, January 17–March 26, 1982. Catalogue text by Greta Berman and Jeffrey Wechslen.

Des Moines Art Center, Iowa. *Giorgio Morandi*, February 1–March 14, 1982. Catalogue text by Kenneth Baker, Joan M. Lukach, Luigi Magnani and Amy Namowitz Worthen.

Museum of Fine Arts, Boston, Massachusetts. *Fairfield Porter (1907–1975): Realist Painter in an Age of Abstraction*, January 12–March 13, 1983. Catalogue text by John Ashbery and Kenworth Moffett. Conversation with Fairfield Porter conducted by Paul Cummings.

National Gallery of Art, Washington, D.C. *Important Information Inside: The Art of John F. Peto and the Idea of Still-Life Painting in Nineteenth-Century America*, January 16–May 29, 1983. Catalogue text by John Wilmerding.

The Phillips Collection, Washington, D.C., in association with George Braziller, Inc., New York City. *Morris Graves: Vision of the Inner Eye*, April 9–May 29, 1983. Catalogue text by Ray Kass.

BOARD OF TRUSTEES

Mrs. Louis Adler
Mrs. E. Rudge Allen, Jr.
Mr. Robert H. Allen
Mr. Eugene E. Aubry, *Vice President*
Mrs. A. L. Ballard, *President*
Mr. Leon W. Blazey, Jr., *Treasurer*
Mrs. Lewis Brazelton III
Mr. Breaux B. Castleman
Mrs. O. Donaldson Chapoton
Mr. Jonathan Day
Mr. Jerry Finger
Ms. Joan H. Fleming
Mrs. Russell M. Frankel
Ms. Susan G. Glesby
Mrs. Henry Hamman
Mr. Ford Hubbard, Jr.
Mr. Luke Johnson, Jr.
Mrs. I. H. Kempner III, *Chairman*
Mr. Benjamin F. Kitchen III
Mrs. Francisco Lorenzo, *Vice President*
Mrs. Marilyn Lubetkin
Mrs. Stewart Masterson
Mrs. Sanford E. McCormick, *Vice President*
Mrs. Robert N. Murray
Mrs. Roy S. O'Connor, *Secretary-Parliamentarian*
Mrs. Sue R. Pittman
Mrs. John D. Roady
Ms. Helen R. Runnells
Ms. Miki Sarofim
Mr. David N. Scoular
Mr. Marc J. Shapiro
Mr. L. E. Simmons
Mr. Richard Stowers Smith
Mr. William F. Stern
Mrs. Robert D. Straus
Mr. McClelland Wallace

STAFF

Catherine Angel,
Assistant to the Head Security Officer

Ellen Anspon,
Assistant to The Museum Shop Manager

Vicki Bailey,
Membership Secretary

Michael J. Barry,
Head Preparator

Linda L. Cathcart,
Director

Emily Croll,
Registrar

Mary Cullather,
Receptionist/Secretary

Jamet Foreman,
Bookkeeper

Dana Friis-Hansen,
Program Coordinator

Clay Henley,
Assistant Preparator

Marti Mayo,
Curator

Martha R. Prozeller,
Membership Officer

Pamela A. Riddle,
Development Officer

Sheila Rosenstein,
Coordinator, Members' Sales and Rental Gallery

Alexa Stathacos,
The Museum Shop Manager

Emily L. Todd,
Curatorial Intern

Ernest Vaughn,
Head Security Officer

Timothy Walters,
Publications and Public Information Officer

Photographic credits

Albright-Knox Art Gallery, Buffalo, New York: p. 85 (bottom)

Archer M. Huntington Art Gallery, The University of Texas at Austin: p. 111

David Behl: p. 83 (bottom)

Leo Castelli, New York City: p. 81

Chisholm, Rich & Assoc. Photography, Houston, Texas: p. 62

Geoffrey Clements Photography, Staten Island, New York: pp. 38, 71, 80, 99, 108 (top and bottom) © Geoffrey Clements

Davis & Langdale Company, Inc., New York City: p. 117

D. James Dee, New York City: p. 65

eeva-inkeri, New York City: pp. 39, 57, 59, 63, 75, 77, 79, 89 (top and bottom), 92 (bottom), 98 (bottom), 104 (left and right)

Fischbach Gallery, New York City: pp. 47, 51 (top and bottom), 60, 61, 114

Allan Finkelman: p. 97 (left)

Xavier Fourcade, Inc., New York City: p. 84

Allan Frumkin Gallery, New York City: p. 98 (top)

Rick Gardner Photography, Houston, Texas: pp. 94, 110 (bottom)

Collection of Graham Gund: p. 109

Helga Photo Studio, Upper Montclair, New Jersey: pp. 83 (top), 93 (left)

Hickey & Robertson, Houston, Texas: p. 91

Sidney Janis Gallery, New York City: p. 97 (left and right)

Bruce C. Jones Fine Art Photography: p. 87

David McKee Gallery, New York City: pp. 68, 69

A.F. Madeira: p. 107

Louis K. Meisel Gallery, New York City: pp. 58 (top and bottom), 90

The Metropolitan Museum of Art, New York City: p. 76

Robert Miller Gallery, New York City: pp. 56, 74, 88

Alexander F. Milliken Inc., New York City: p. 51 (top and bottom)

The Minneapolis Institute of Arts, Minnesota: p. 96

Moody Gallery, Houston, Texas: p. 113

Al Mozell, New York City: p. 102 (top and bottom)

Nebraska Art Association, Courtesy of Sheldon Memorial Art G University of Nebraska-Lincoln: p. 70

Joseph Painter: pp. 93, 102

Douglas M. Parker, Los Angeles, California: p. 73

Pelka/Noble, New York City: p. 50 (top and bottom)

Robert Schoelkopf Gallery, New York City: pp. 82 (top), 92 (botto 112

San Francisco Museum of Modern Art, California: p. 101

Schneck & Schneck Photography: p. 49 (top)

Steven Sloman: p. 43

Spencer Museum of Art, The University of Kansas, Lawrence: p

Studio/Nine Inc., New York City: p. 116

Texas Gallery, Houston, Texas: p. 63 (left)

© The Toledo Museum of Art, 1979: p. 44

Tom Vinetz, Venice, California: pp. 49 (bottom), 52 (top)

David Webber: pp. 53, 110 (bottom)

Zindman/Fremont, New York City: pp. 48, 55, 78 (right), 105

666 980

Designed by Creel Morrell Inc.
Typesetting: G & S Typesetters Inc.
6,000 copies printed by
Communication Specialists Inc.